# Virgin Portraits

Page 4:
*The Crowned Virgin*
Jean-Auguste-Dominique Ingres, 1859
oil on canvas, 69 x 50 cm. Tamenago Gallery, Tokyo

Designed by :
Baseline Co Ltd
19-25 Nguyen Hue
Bitexco Building, Floor 11
District 1, Ho Chi Minh City
Vietnam

ISBN 1-84013-741-X

Published in 2005 by Grange Books
an imprint of Grange Books Plc
The Grange Kingsnorth Industrial Estate
Hoo, nr Rochester, Kent ME3 9ND
www.grangebooks.co.uk

Printed in China

# Foreword

"During the Renaissance, Italian painters would traditionally depict the wives of their patrons as Madonnas. The artists would often overstate the beauty of their models, rendering them more beautiful than they actually were. The contemporary representation of the Mother of Christ, however, tended to remain unchanged. With the passing of time, Mary gradually lost some of her spiritual characteristics and became more humane, more accessible to human sentiments."

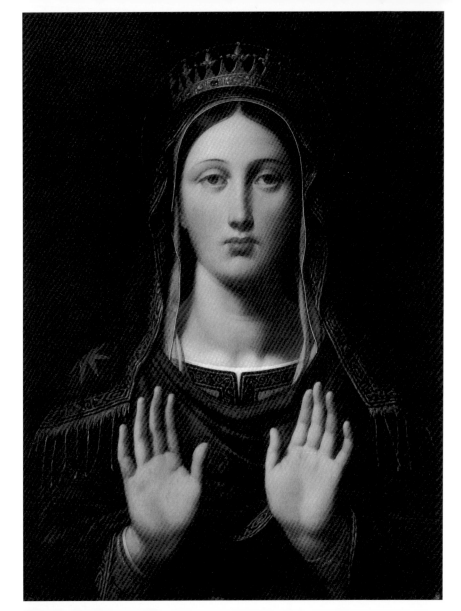

# Contents

Mary Cassatt

Frida Kahlo

Bertha Morisot

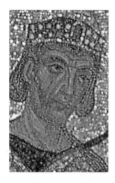

The image of the Madonna has been embedded in the arts of the Western World for nearly two thousand years. She embodies the purest form of unconditional love and is perceived as the compassionate and forgiving nurturer of all Christian people. The Madonna is also seen as the loving mother, and the protector of all humanity.

Mary with the Child Jesus
between Constantine and Justinian

---

Anonymous, Xth century
lunette mosaic
Hagia Sophia, Constantinople (Istanbul)

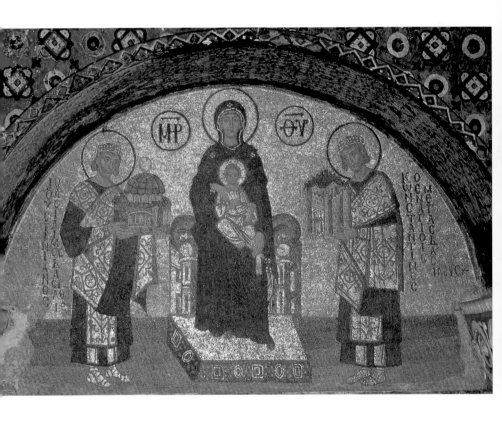

Her followers believe that only she can fully understand human grief, passions and happiness; she forgives, mediates, and consoles, and she is the connection between human beings and their God. She has been venerated as the Queen of Heaven, the Mother of All, and as the embodiment of compassion.

The Virgin of Vladimir

Anonymous, XIIth century
tempera on wood, 78 x 55 cm
Tretiakov Gallery, Moscow

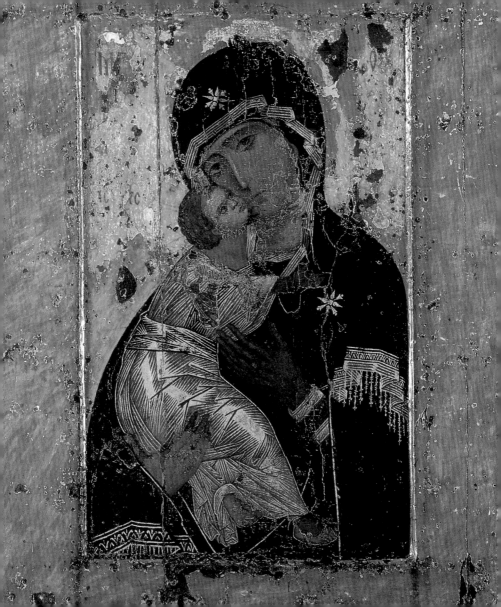

She is seen as selfless, humble, and caring, and represents the feminine spirituality within Christianity. For many centuries the Madonna has inspired thousands of artists who laboured innumerable hours creating her images using different styles, materials, and techniques.

Rucellai Madonna

Duccio di Buoninsegna, 1285
tempera on wood, 450 x 290 cm
Uffizi, Florence

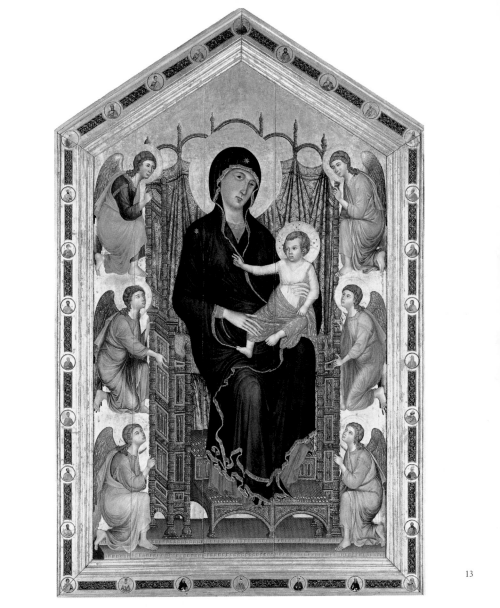

13

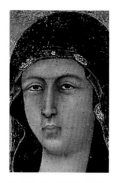

This huge body of artwork, a cultural legacy of major proportions, represents a social system that still dominates the world. Art museums, galleries, palaces and private collections are filled with her icons. Through the centuries, images of the Virgin were created according to the religious interpretations of beliefs, myths, iconography and symbolism prevalent at the time.

Madonna of Mercy

Simone Martini, 1308-1310
tempera on wood, 154 x 84 cm
Pinacoteca Nazionale, Siena

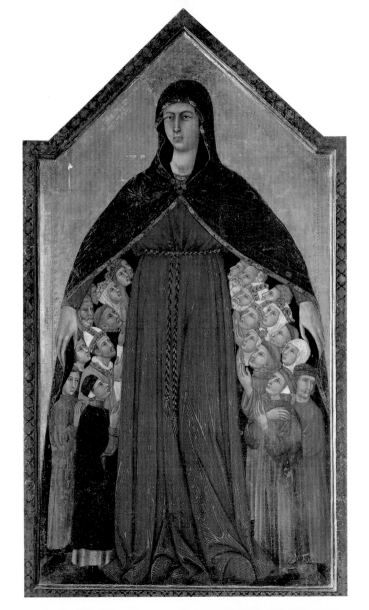

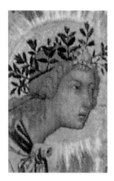

The presence of Mary in the heart of Western civilization has a long theological history of transformation. Scholars concur that during early Christianity there were other paramount feminine faces of spirituality, such as Sophia, who was understood to be the feminine aspect of the complex Christian God.

The Annunciation, with Saints Ansanus and Margaret and Four Prophets

Simone Martini and Lippo Memmi, 1333
tempera on wood, 184 x 210 cm
Uffizi, Florence

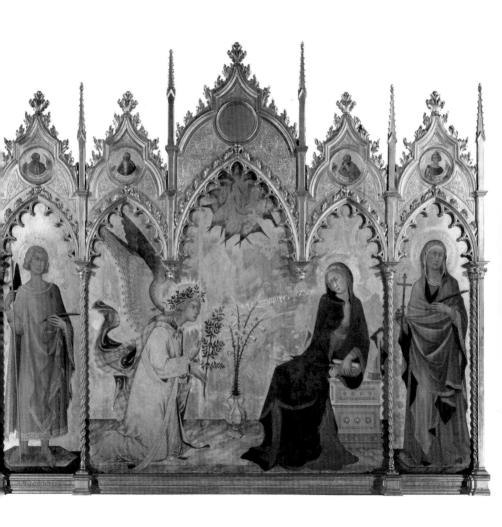

17

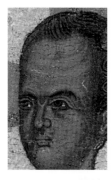

Hagia Sophia represented the Divine Wisdom and was celebrated as a co-creator, together with the Father, the Son and the Holy Spirit. At the beginning of Christianity, particularly in Eastern Europe, the Holy Ghost was understood as female. Yet it usually was Sophia who was celebrated as the feminine aspect of the divine.

## The Virgin and Child

Lorenzo Veneziano, 1356-1372
painting on wood, 126 x 56 cm
The Louvre, Paris

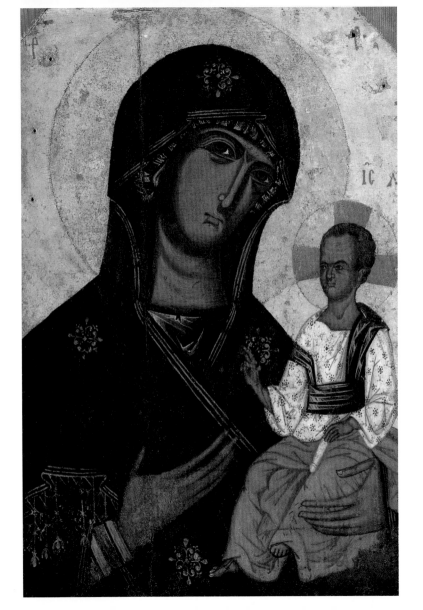

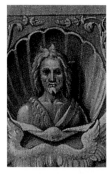

As Sophia's popularity among the dogma-generating clergy waned, the popularity of the Virgin Mary, the Mother of God, gradually increased.

During the sixth century, the presence of the Mother of God was reaffirmed within the Christian religious dogma all over Europe, including the Byzantine Empire.

Madonna and Child

Luca Signorelli, c.1390
oil on wood, 170 x 117.5 cm
Uffizi, Florence

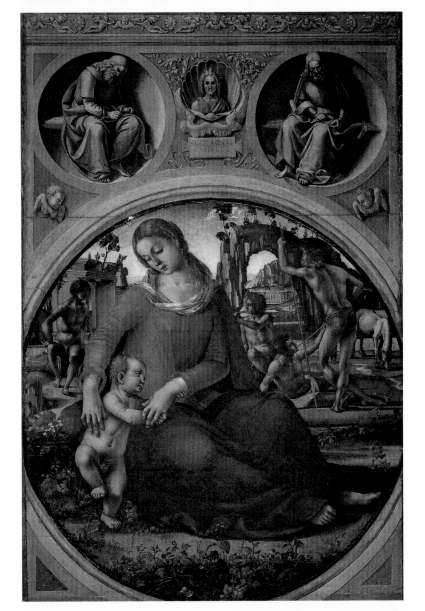

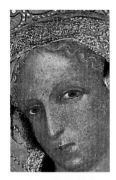

This affirmation effectively neutralized the threat of a competing religion, that of the Great Goddess Isis of Egypt. During early centuries A.D. the image of Mary was frequently equated to and even confused with the image of the Egyptian goddess whose religion had been in existence for several thousand years.

Madonna of the Misericordia
_____

Jacobello Alberegno, c.1394
Galleria dell'Accademia, Florence

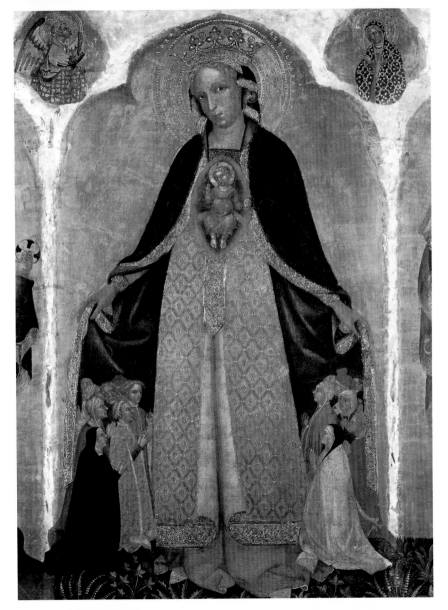

23

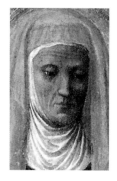

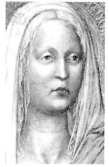

Like the Madonna, the Goddess Isis also had a divine son, Horus, and artists often depicted her tenderly holding her precious infant on her lap and suckling him. One of her main characteristics was that of a nurturing mother. She was, like Mary, a compassionate and loving divinity, ultimately dedicated to her people's well-being.

### The Virgin and Child and Saint Anne Metterza

Masolino da Panicale and Masaccio, 1424
tempera on wood, 175 x 103 cm
Uffizi, Florence

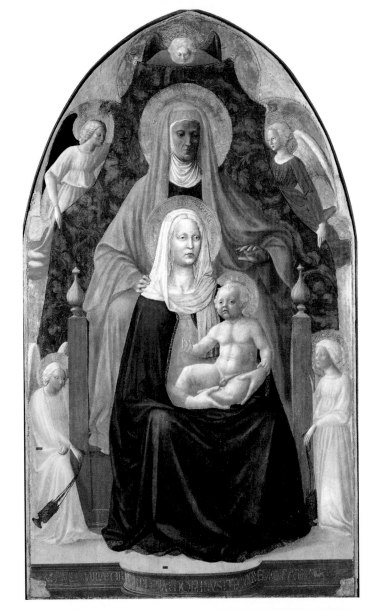

During the eighth century, the iconoclastic movement banned all sacred images located within the Byzantine empire, believing that the worshippers were venerating the actual images instead of the spiritual beings. However, this decision was permanently reversed by the following century, and the creation of icons dedicated to the Virgin Mary resumed with fervour.

Saint Luke Painting the Virgin

Rogier van der Weyden, c.1450
oil on wood, 138 x 110 cm
Alte Pinakothek, Munich

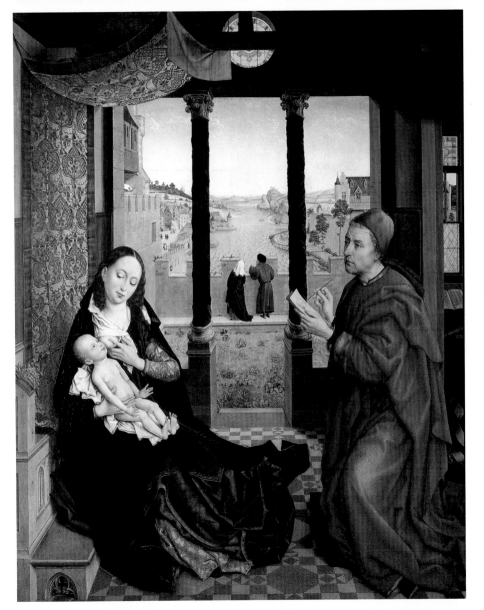

Besides the Goddess Isis, statues or icons of other pagan goddesses were often reinterpreted as images of Mary during early Christianity. One of them was the ancient Greek earth goddess Demeter, who also had a child, Persephone, the resurrecting goddess of spring.

Madonna della Cintola
_____

Benozzo Gozzoli, 1450-1452
tempera on wood
Vatican Museum, Rome

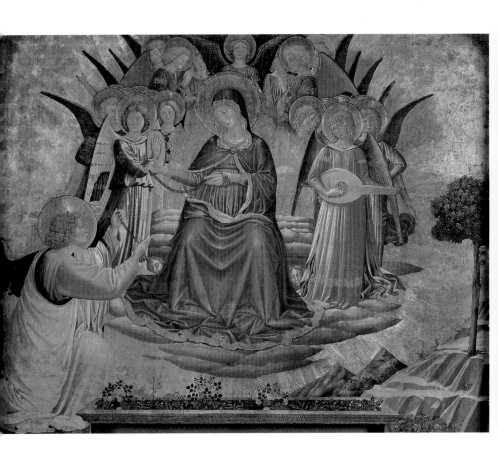

Another such goddess was Artemis/Diana of the Greco-Roman world. Cybele, originally from the Near East, was also often viewed as an early version of Mary. Each of these goddesses had a long history of veneration. Complex rituals were performed to celebrate them and numerous temples were built in which to worship them.

Madonna and Child with Stories of the Life of Saint Anne (Bartolini Tondo)

---

Filippo Lippi, 1452
tempera on wood, diameter: 135 cm
Pitti Palace Gallery, Florence

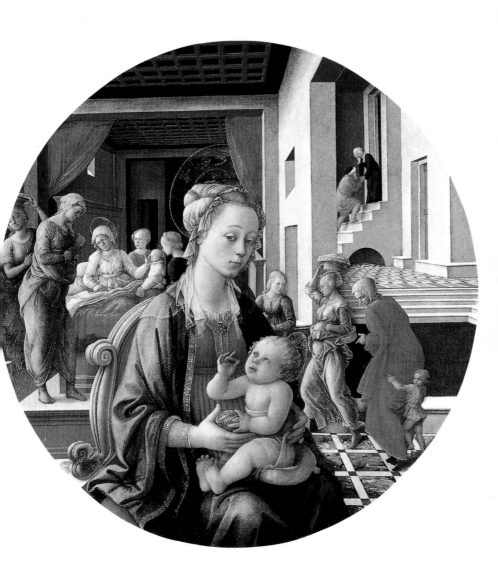

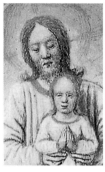

During these times the newly established patriarchal societies retained strong matriarchal components that were still firmly embedded within their structure. Women often therefore possessed considerable rights and powers. Consequently, the feminine spiritual powers were celebrated within their religious structures.

"The Death of the Virgin"
Book of Hours of Etienne Chevalier

Jean Fouquet, 1452-1460
Illuminated Manuscript
Condé Museum, Chantilly

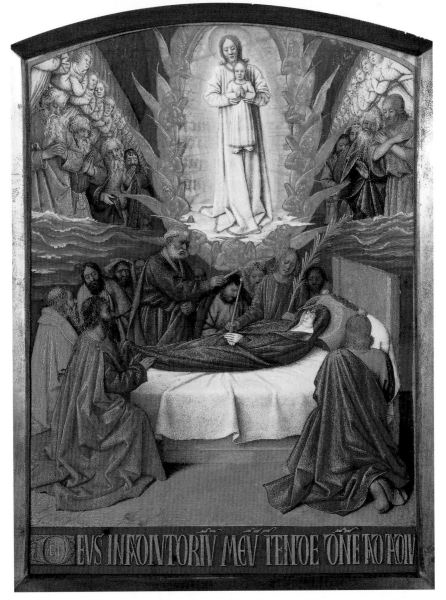

EVS IN ꝭOIVTORIV MEV TENOE ꝉONE ꝫO ꝉOꝉ

33

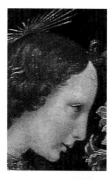

The divinities of both genders were worshipped within these societies with equal ardour and reverence. A number of these goddesses and gods from the religions of the ancient world later became very popular Christian saints, and many churches were dedicated to them.

The Annunciation

Leonardo da Vinci, c.1470
oil and tempera on wood, 98 x 217 cm
Uffizi, Florence

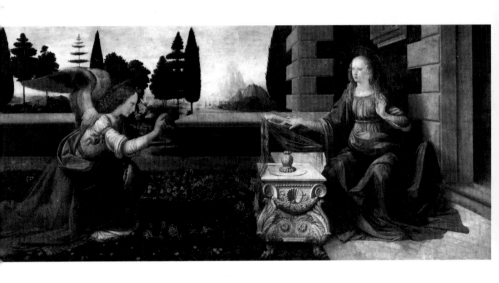

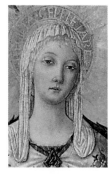

Beneath the layers of goddess images and temples created by the artists of the pagan world, there is another, earlier layer of art that was produced by prehistoric men and women to celebrate their Mother God. Early images of the Great Goddess of Neolithic and Paleolithic Europe that survived the test of time, were often carved out of stone.

The Assumption of the Virgin
_____

Matteo di Giovanni, c.1474
tempera on wood, 331.5 x 174 cm
National Gallery, London

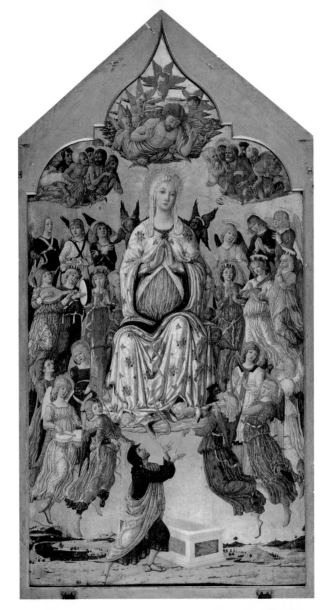

37

Marija Gimbutas, an archeologist and author of several volumes of texts on the history of prehistoric matriarchal cultures of Europe, describes in detail the societies that produced images of the Mother Goddess. These pre-historic social systems were matriarchal.

The Madonna of the Apocalypse

Jean Hey, 1480-1500
oil on wood
Moulins' Cathedral, France

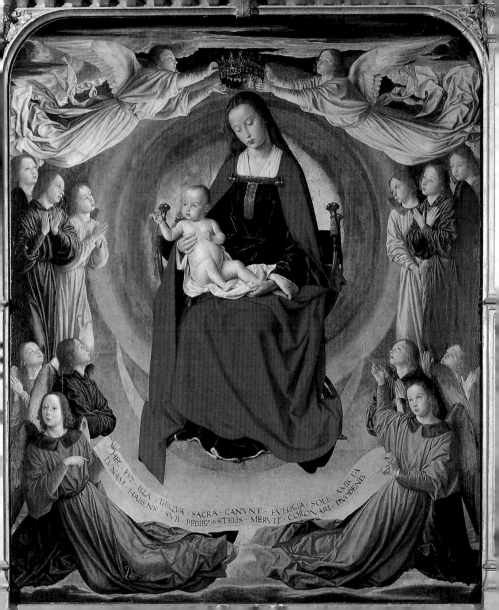

The creator god was visualized in female form since people's beliefs reflected a social order that was essentially organized and implemented by the women of these cultures.

An abundance of images that represent the oldest religious belief system of humanity has been unearthed and these images can be viewed at major museums around the world.

The Virgin and the Child

Sandro Botticelli, 1480
painting on wood, 58 x 39.6 cm
Museo Poldi Pezzoli, Milan

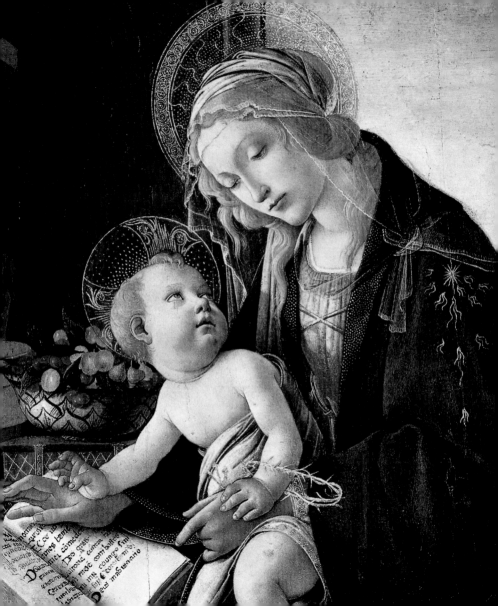

The earliest of these images in Europe is considered to be the Venus or Goddess of Willendorf, and she is dated at around 35,000 BC. These prehistoric icons of the goddess are the most distant ancestors of Mary. Under the strictly patriarchal social order of the last two millennia, the role of the female gender was clearly defined as subservient and less valuable than the role of the male gender.

The Madonna Benois

Leonardo da Vinci, c.1480
oil on canvas, 49.5 x 31.5 cm
The Hermitage, St. Petersburg

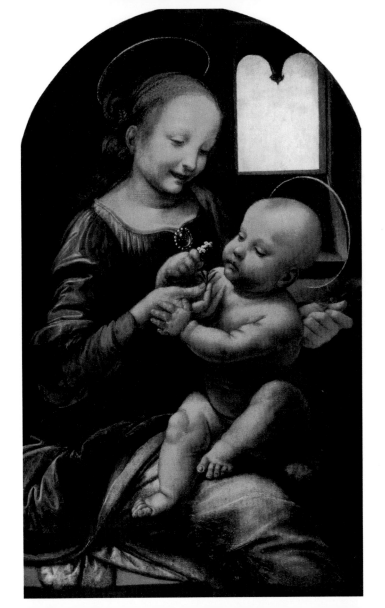

Therefore, it was no longer possible to sustain the belief in a female divinity within the Christian dogma.

Yet the Madonna retained her occult divine status, often apparent through the symbolic messages incorporated into her iconography by the artists who created her icons.

## The Annunciation

Lorenzo di Credi, 1480-1485
oil on wood, 88 x 71 cm
Uffizi, Florence

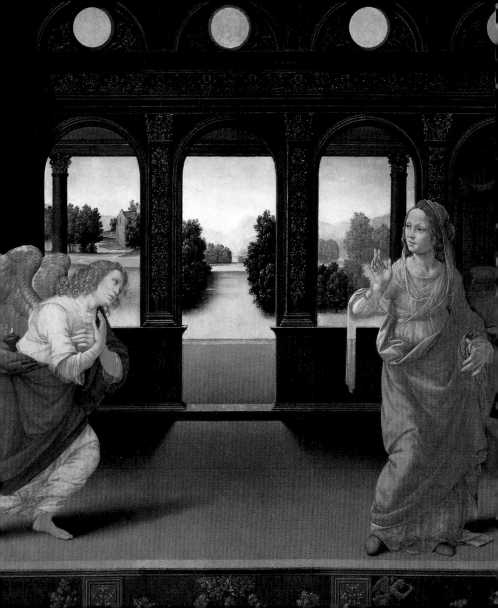

For the last five centuries, as the Western world expanded its boundaries into the rest of the globe, many new temples dedicated to the Virgin Mary were built directly upon the sites of the old Mother Goddess temples of the indigenous cultures.

## The Madonna of the Magnificat

Sandro Botticelli, 1481-1485
tempera on wood, diameter: 118 cm
Uffizi, Florence

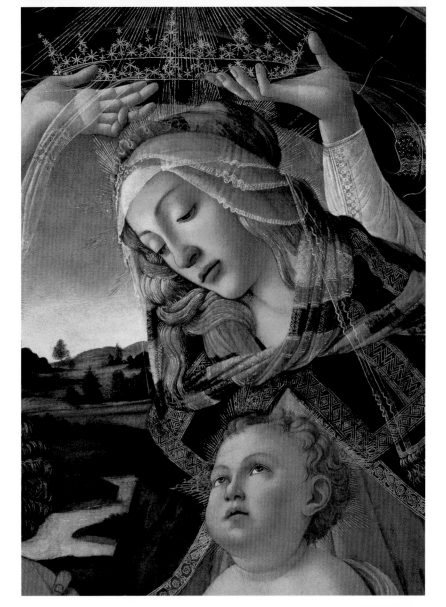

After the conquest of the Americas, countries such as Mexico and Peru made a significant artistic contribution of images dedicated to Mary. Like her European counterparts, these images often depicted the Holy Virgin as the Black Madonna, considered to be miraculous and powerful.

The Adoration of the Child

Francesco Botticini, 1482
tempera on wood, diameter: 123 cm
Pitti Palace Gallery, Florence

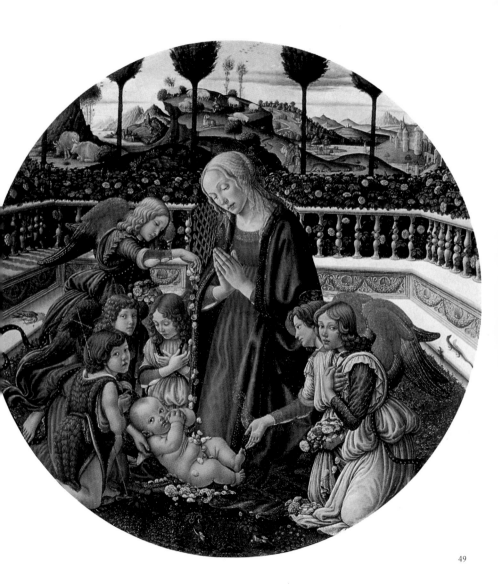

49

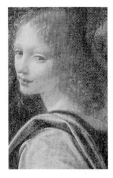

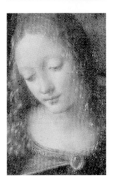

Within the new continent, the Virgin Mary often assumed the role of the former regional mother goddess, and became the patron of the particular region or of an entirely new country. Additional symbols, previously representing the native divinities, were then incorporated into the Marian iconography.

The Virgin of the Rocks

Leonardo da Vinci, 1483
oil on canvas, 199 x 122 cm
The Louvre, Paris

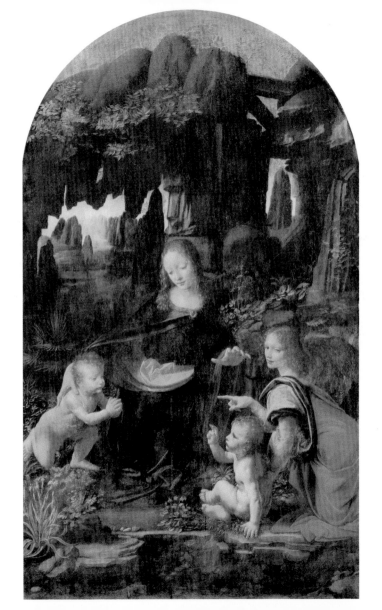

Consequently, the new populations perceived the Virgin Mary as the Christian Mother of God, and, at the same time, as the indigenous Mother God of the earlier, conquered civilizations. All indications show that the role of the Madonna is still evolving.

The Birth of Venus

Sandro Botticelli, 1484-1486
tempera on canvas, 172.5 x 278.5 cm
Uffizi, Florence

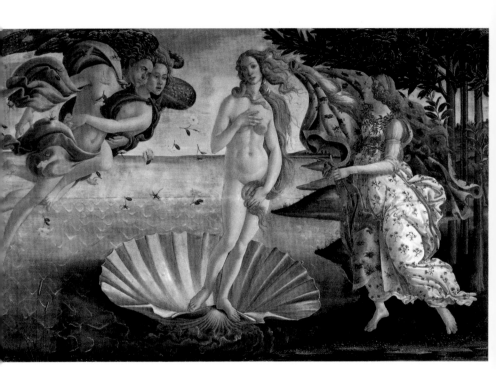

The lore, the origins, the dogma, the myths and the expanding array of symbols and archetypes continue to surround the enigmatic persona of the Virgin Mary. As a prototype of spirituality and perfection in womanhood, the Madonna looms larger than life.

The Madonna and Child with Saints John the Baptist, Victor, Bernard, and Zenobius

Filippino Lippi, 1486
tempera on wood, 355 x 255 cm
Uffizi, Florence

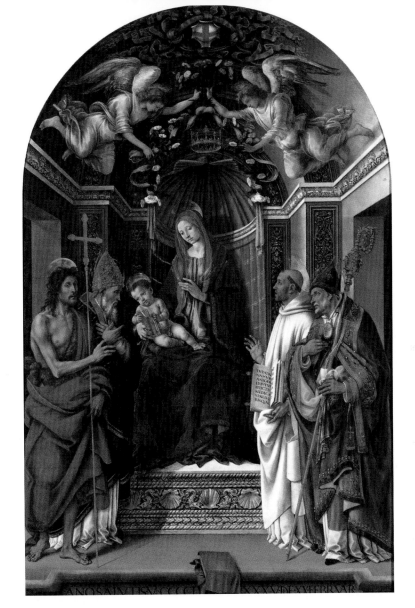

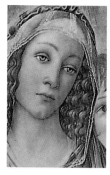

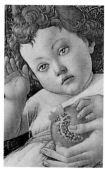

This book offers the reader some of the best art that has been produced through the centuries to celebrate Mary.

The works of art were created by many different individuals who tried to convey and explain, from their different points of view and using the visual language available to them, the depth of the feelings and convictions of their cultures in respect of this Great Mother.

## The Madonna of the Pomegranate

Sandro Botticelli, 1487
tempera on wood, diameter: 143.5 cm
Uffizi, Florence

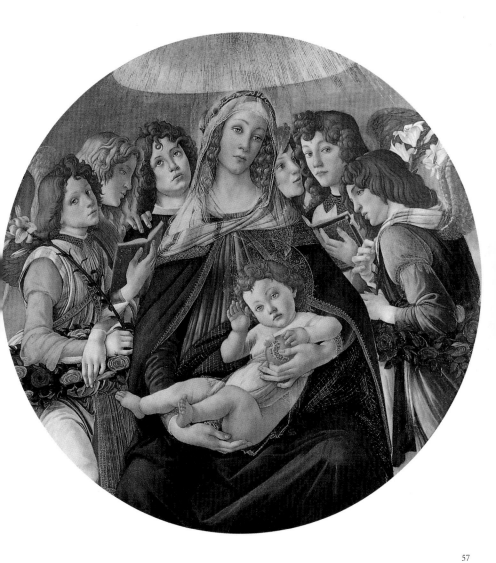

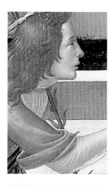

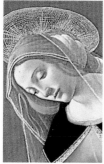

The earliest images of Mary were probably introduced into early Christian iconography during the second and third centuries. This was a time in human history when society was committed to relieving women of their remaining rights and powers; vestiges of the old matriarchal rights were banned from the prevalent patriarchal order.

The Annunciation

Sandro Botticelli, 1489
tempera on wood, 150 x 156 cm
Uffizi, Florence

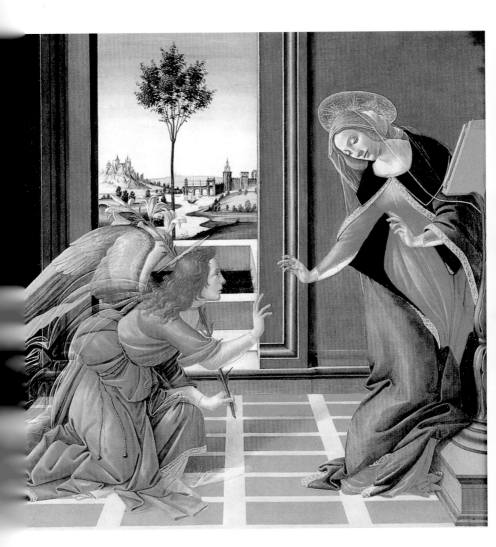

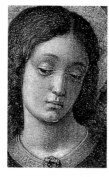

The officially accepted Gospels of the New Testament were written by males for a patriarchal social system, and very few references about the Madonna were made in these texts. Neither Mary nor her son, Jesus, wrote any material, and the first official Gospel, believed to be written by Mark, was completed in its unedited version in 66.

## The Madonna of the Caves

Andrea Mantegna, 1489-1490
tempera on wood, 29 x 21.5 cm
Uffizi, Florence

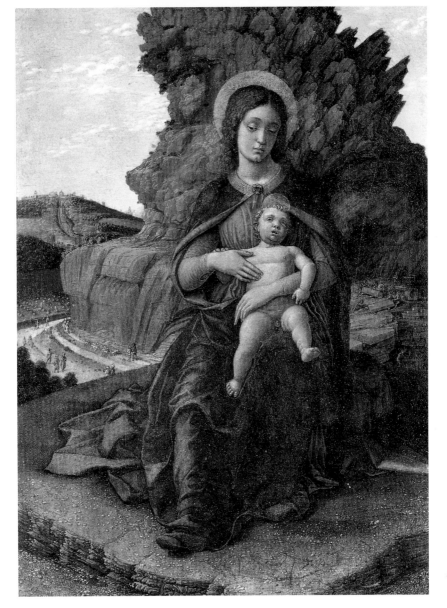

61

Apparently the second official version of the Gospels was written by Luke in 80, shortly followed by Matthew's version. It is possible, however, that John's version was in fact the earliest one, at around 37, since it includes more details, which have led many to believe that perhaps this version may be closer to the real occurrences of the events in the lives of Mary and her son, Jesus.

The Madonna and Child with Two Angels

Hans Memling, 1490-1491
oil on wood, 57 x 42 cm
Uffizi, Florence

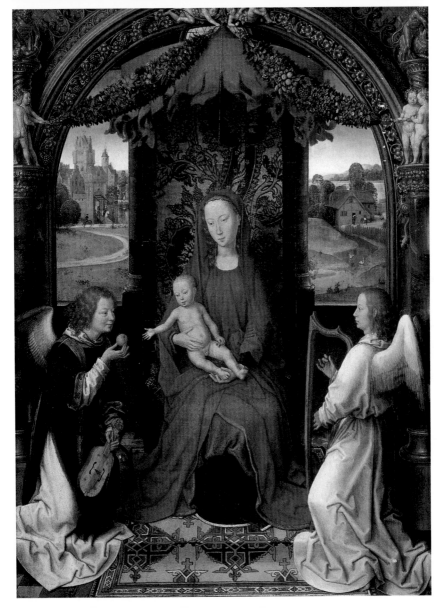

63

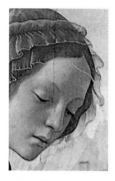

These accounts, primarily from the story of Jesus, mentioned his mother on very rare occasions, and were not nearly enough to satisfy the people, who, in spite of the patriarchal trivializing of women, desperately desired a divine female figure to worship and venerate.

The Visitation

Domenico Ghirlandaio, 1491
oil on wood, 172 x 167 cm
The Louvre, Paris

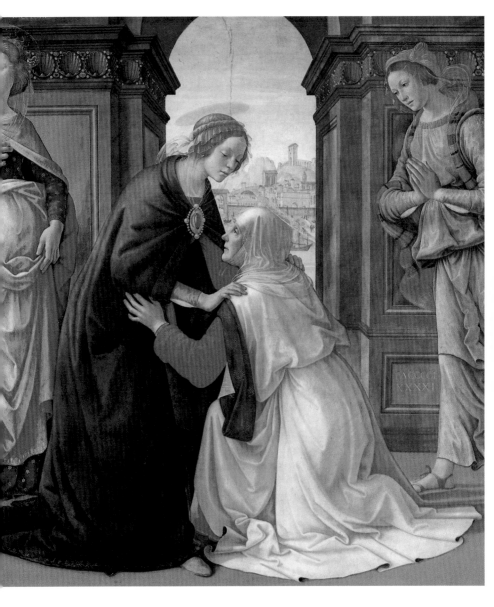

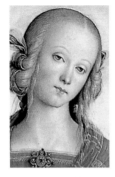

The yearning for the powerful but gentle Great Mother could not be silenced, and the worship of the goddesses from the old religions, such as Isis, Cybele, Demeter, Aphrodite and Athena continued. The devotion to Isis was, perhaps, the most widespread, posing a formidable threat to the fledgling Christian cult.

The Virgin and Child
Accompanied by Two Angels
Saint Rose and Saint Catherine

Perugino, c.1492
oil on wood, diameter: 148 cm
The Louvre, Paris

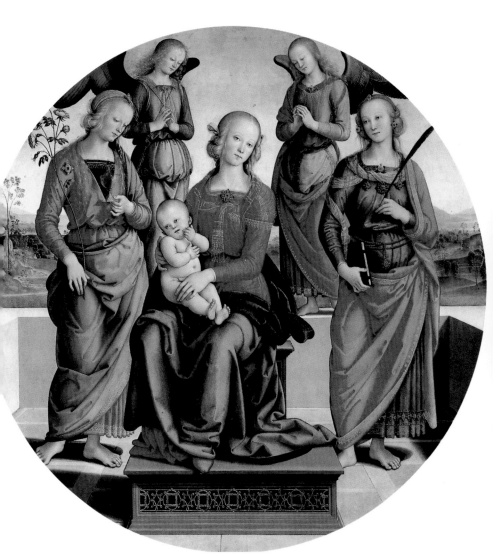

The new Christian religion needed its own Great Mother, and that Mother manifested herself first in the early interpretations of the Holy Ghost as female, and of Sophia as the Wisdom of God. These powerful female archetypes of the new predominantly patriarchal religion were soon overshadowed by the inclusion of Mary, the mother of Christ.

Presentation of the Virgin at the Temple

Nicolas Dipre, c.1500
painting on wood, 33 x 51 cm
The Louvre, Paris

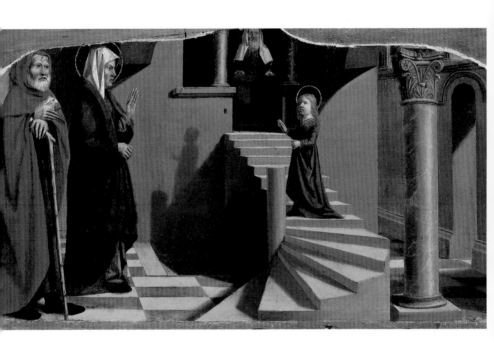

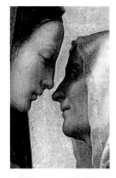

From the beginning, the Madonna was seen as the symbol for the Mother Church herself. The presence of the Madonna was critical to the universal acceptance of Christianity in Europe, both eastern and western; her presence created a bridge that allowed the followers of the matriarchal goddess-worshipping religions to join the new patriarchal cult.

The Visitation

Mariotto Albertinelli, 1503
oil on wood, 232 x 146, cm
Uffizi, Florence

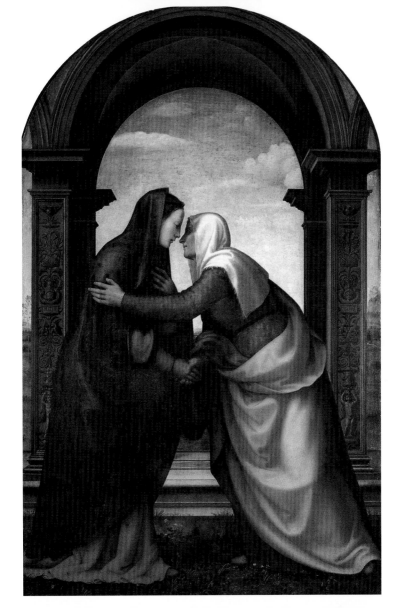

A complex Marian dogma was gradually developed by the clergy, always in response to the public's needs and desires to worship and venerate this divinity.

However, the Christian dogma of the early centuries included another powerful female figure, the mysterious Sophia, or the Word of God, as the female element within the Creation.

The Holy Family with the
Young Saint John the Baptist (Doni Tondo)

Michelangelo, 1504-1507
oil on wood, diameter: 120 cm
Uffizi, Florence

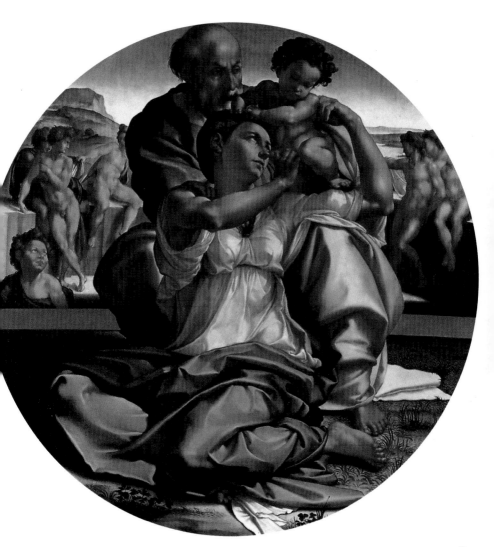

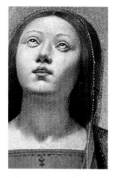

Many early images were dedicated to her, and Mary, the Mother of God, was often represented as Mary/Sophia. In addition, the parallels between the images of Mary and the images of the Goddess Isis contributed to the acceptance of Christianity by a large sector of the medieval population that formerly worshipped Isis and other female gods.

The Immaculate Conception and Six Saints

Piero di Cosimo, c.1505
oil on wood, 206 x 172 cm
Uffizi, Florence

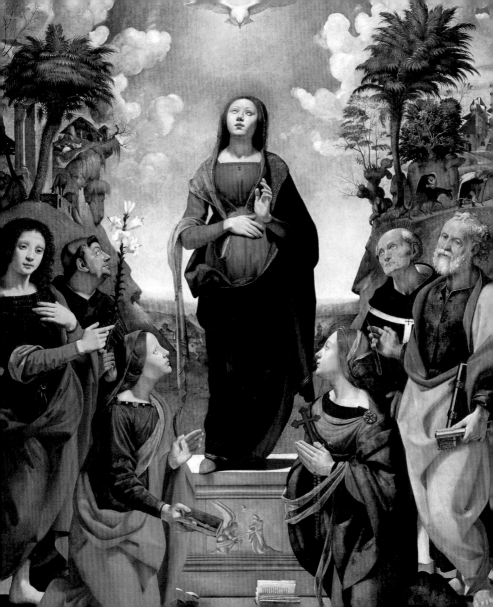

This last development unified and cemented Christianity as the dominant religion of both eastern and western Europe. The Marian artists promptly adopted numerous symbols of the goddesses for iconographic purposes, further eliminating any doubts in the mind of the worshippers that their Universal Mother was no less important than the female divinities of previous religions.

The Madonna of the Goldfinch

Raphael, 1505-1506
oil on wood, 107 x 77.2 cm
Uffizi, Florence

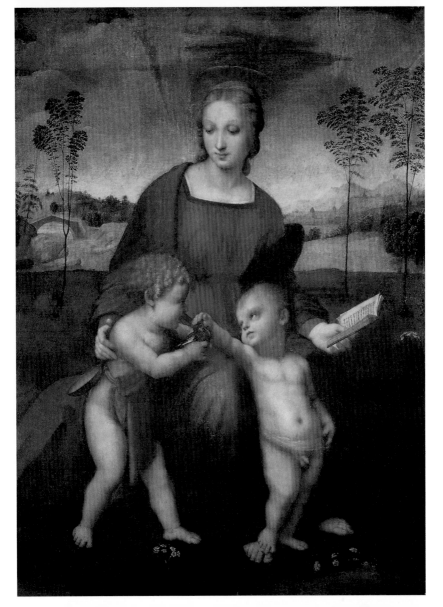

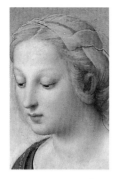

In the meantime, in response to the needs of the Christian population searching for a female divine principle, Marian iconography, cult, and dogma were gradually created and refined. But the Fathers of the Church were keenly aware that their ascetic religion, which saw sexuality as a form of evil and women as more sexual and physical than men, needed to fortify and reaffirm the virginity of Mary to further separate her from the rest of womanhood, which most of them believed to be evil and inferior to men.

La Belle Jardinière

Raphael, 1507
oil on wood, 122 x 80 cm
The Louvre, Paris

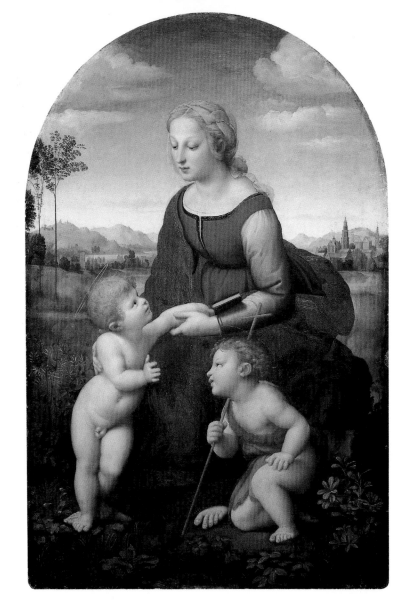

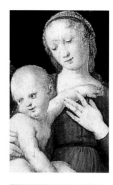

The myth of the virgin birth is not unique to Christianity. In many ancient and pagan religions a goddess gives birth to a daughter or a son without any help from a god, a phenomenon known as parthenogenesis. While in prehistoric Europe and its vicinity the creator was worshiped in female form, in late prehistoric times the Great Mother Goddess finally multiplied herself by giving birth to the first male divinity, her son.

The Madonna of the Baldacchino

Raphael, 1507
oil on wood, 279 x 217 cm
Pitti Palace Gallery, Florence

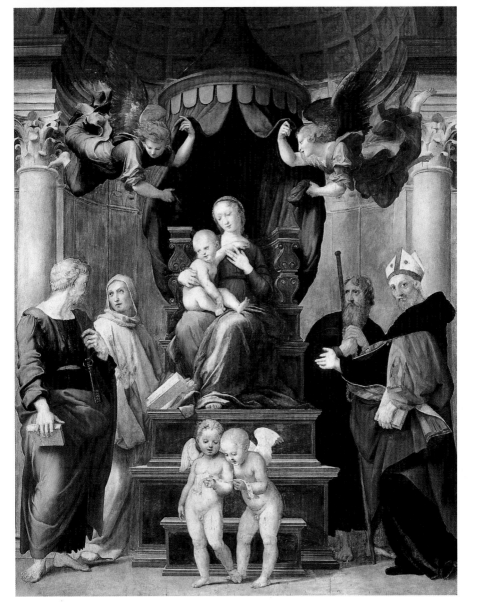

Mary's virginal state was ultimately paramount to the Church leaders. It not only represented the Church's aversion to sexuality, particularly in women, but also a new hope for redemption from Original Sin, a redemption from the sins of the sexual Eve who earlier plunged the whole of humanity into its sinful and inferior existence.

The Holy Family with Saint Catherine
Saint Sebastian, and a donor

Sebastiano del Piombo, c.1507-1508
oil on wood, 95 x 136 cm
The Louvre, Paris

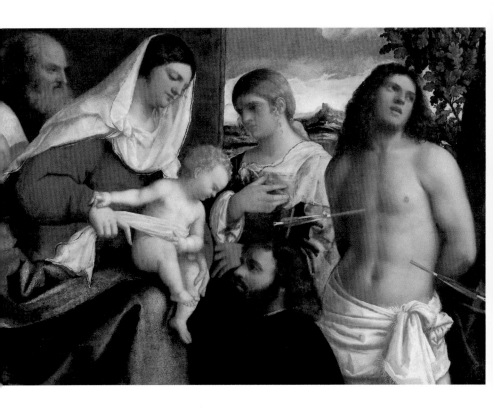

In fact, the Virgin was seen as the Second Eve, the perfect redeemer that would slay the serpent of corruption and save humanity from Eve's evil transgression and disobedience of the patriarchal God. According to the dogma, Mary was the paragon of virtue and obedience to the same God, and the ideal example that would encourage women and men to also remain virginal. Christ, incarnated through the Virgin, was also seen as virginal.

The Virgin and Child with Saint Anne

Leonardo da Vinci, c.1510
painting on wood, 168 x 130 cm
The Louvre, Paris

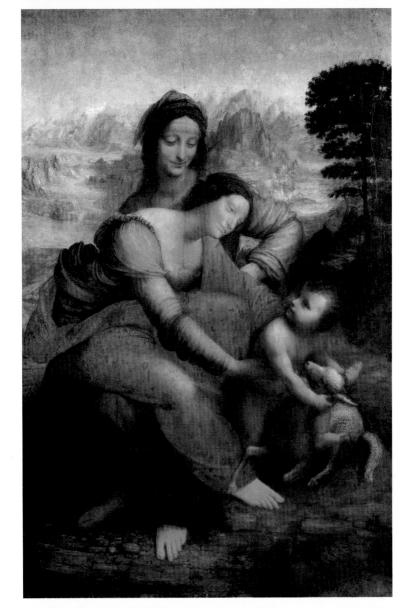

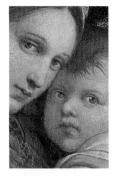

Both Mary and Jesus, therefore, were to save humanity from the corruption of the flesh, sexuality, and eventually, from death.

The adoration of Mary inspired specific themes in the visual arts. Various myths that highlighted important Marian events were clearly formulated by the artists.

The Madonna of the Chair

Raphael, 1513
oil on wood, diameter: 71 cm
Pitti Palace Gallery, Florence

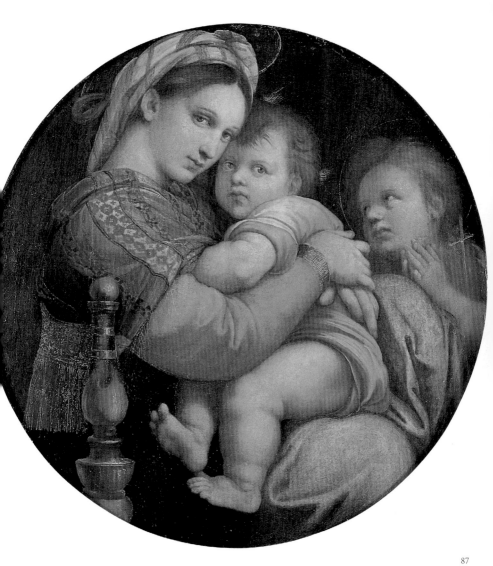

These themes included episodes from her childhood, her engagement to Joseph, the Annunciation by the Archangel Gabriel of the conception of her son, Jesus, the visit of Mary to Elizabeth, the birth of Jesus, or the Nativity, the flight to Egypt, Mary's lament over the body of Christ, her death, her assumption to the heavenly realm, her coronation as the Queen of Heaven, and her many appearances to saints and people.

The Incarnation of Christ

Fra Bartolomeo, 1515
oil on wood, 96 x 76 cm
The Louvre, Paris

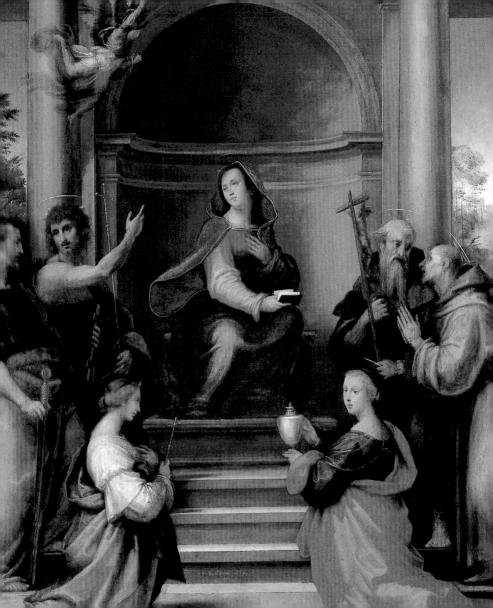

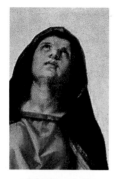

Other images revealed her role as the protector of the people, or as the giver of abundance, Mary as Sophia, Mary as the New Eve, Mary as the Queen of Heaven, and Mary as the Savior and the maker of miracles, particularly in her role as the Black Madonna.

These themes originated in medieval times, and remained well-defined formulas in art over many centuries.

The Panciatichi Assumption

Andrea del Sarto, 1518
wood panel, 362 x 209 cm
Pitti Palace Gallery, Florence

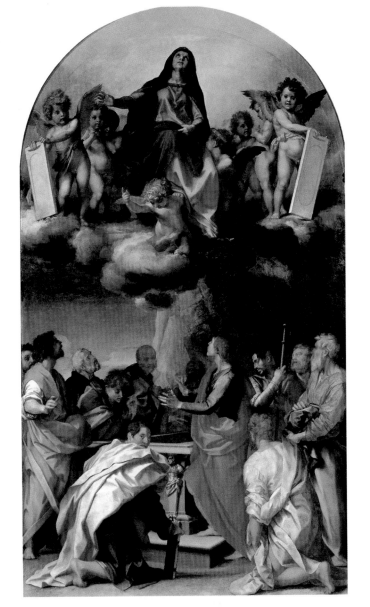

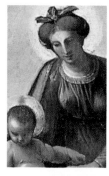

During the first thirteen centuries of Christianity artists employed an abstract style to represent Mary, this approach, used for all Christian iconography, was consistent with the Church's denial of human sensuality: the Christian doctrine, unlike the old earth-based religions, divided the world into the earthly realm and the heavenly realm, the latter of the two being the more desirable.

Madonna in Glory with Saints John
the Baptist and John the Evangelist

Dosso Dossi, 1520-1530
oil on wood (transferred to canvas), 153 x 114 cm
Uffizi, Florence

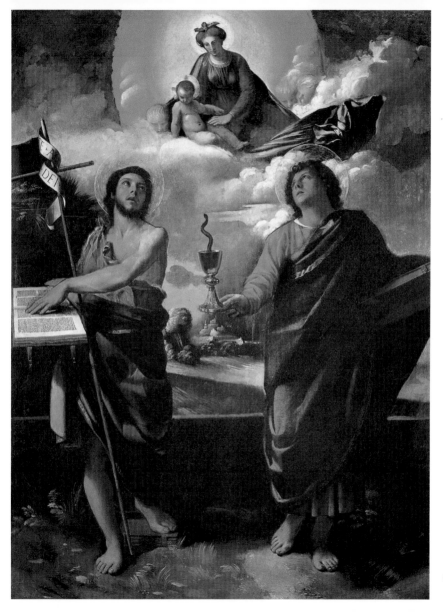

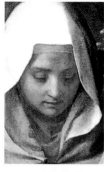

Spirituality was equated with demateri- alization, disembodiment, the absence of all sexual and sensual feelings, and the elevated value of virginity.

Many early Christian works of art were created in the cloisters and monasteries by the clergy, the monks and the nuns. An abstract, linear style was considered the most appropriate for conveying a spiritual message.

Pietà

—

Andrea del Sarto, 1523
oil on wood, 238 x 198 cm
Pitti Palace Gallery, Florence

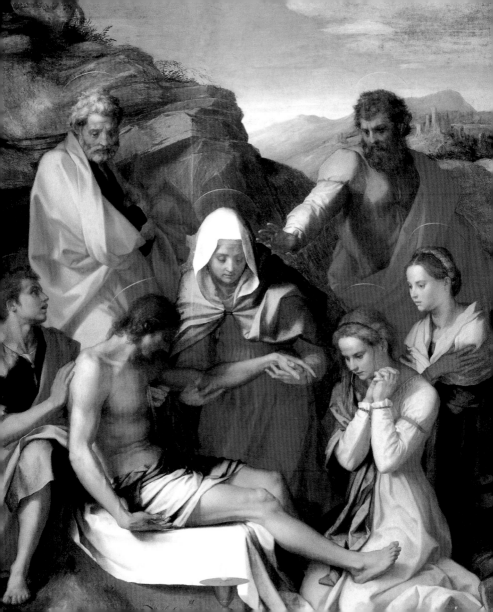

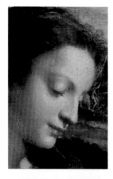

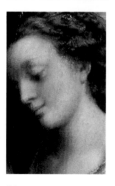

The cult of the Black Madonna, a miraculous and compassionate intercessor for her people, was widespread during early centuries of Christianity, and peaked during the eleventh, twelfth and thirteenth centuries in Europe, particularly in France and in Spain. Variants of this goddess included Cybele, Artemis/Diana and, of course, Isis.

The Mystic Marriage of Saint Catherine with Saint Sebastian

Correggio, c.1526-1527
oil on wood, 105 x 102 cm
The Louvre, Paris

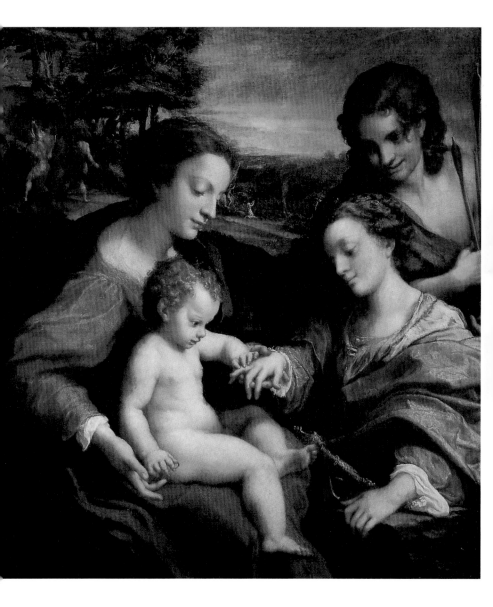

All these goddesses possessed sacred sites with shrines, and were sometimes represented as dark-skinned. In that aspect, the images themselves and the locations of these temples were considered mysteriously powerful and capable of producing miracles. One such statue, among the oldest of the Dark Madonna, is Our Lady of Guadalupe, and is located in her shrine in Spain.

The Visitation

Jacopo Pontormo, 1528-1529
oil on wood, 202 x 156 cm
Church of San Michele, Carmignano

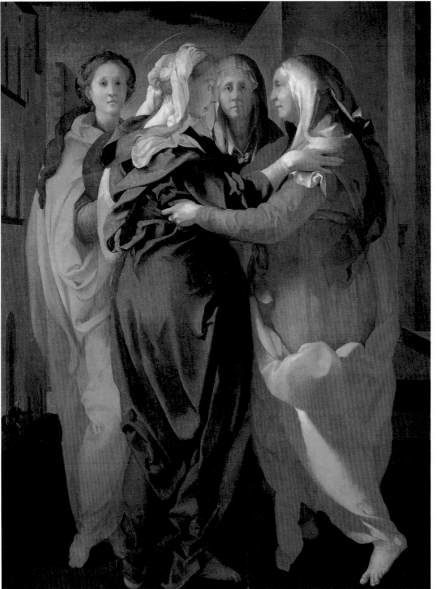

Records indicate that the statue and the shrine have supported an important Marian cult centre since before the seventh century. The Christian doctrine at that time placed Mary as the supreme female figure within the official dogma. But the medieval population had a mind of its own and always believed their Virgin to be fully divine. Common sense indicated to the people that she who is the mother of a god must be a goddess herself.

The Virgin under the Apple Tree
_____

Lucas Cranach the Elder, c.1530
oil on canvas (transferred from wood), 87 x 59 cm
The Hermitage, St. Petersburg

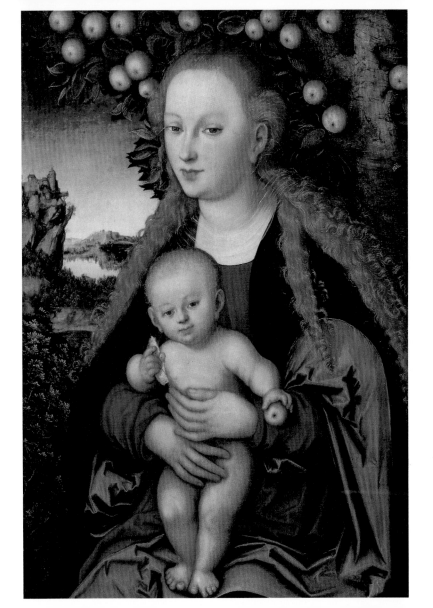

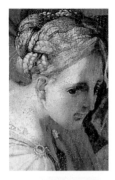

Nuestra Señora de Guadalupe of Mexico City is the officially-declared protector of the people of Mexico.

One of the early masterpieces of Marian iconography is a Byzantine mosaic that is located in the famous cathedral in Constantinople (Istanbul) which was built for and dedicated to Hagia Sophia. It represents Mary, seated on a throne, with the infant Jesus on her lap.

Pietà

———

Rosso Fiorentino, 1530-1535
oil on canvas, 127 x 163 cm
The Louvre, Paris

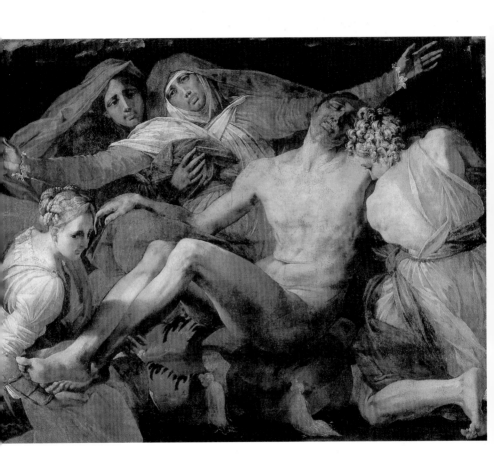

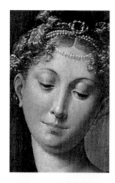

Two emperors are depicted one on each side of the mother and child: Constantine, the founder of the city, and Justinian, who built the Cathedral dedicated to Sophia, the Word of God. At that time, Mary was seen as Sophia the Logos – Creator as well, and her majestic demeanor conveys the message. Mary was also the Theotokos, the Bearer of God, her official title according to the proclamation of the Church Council of Ephesus in 431.

The Madonna with the Long Neck

Parmigianino, 1534
oil on wood, 219 x 135 cm
Uffizi, Florence

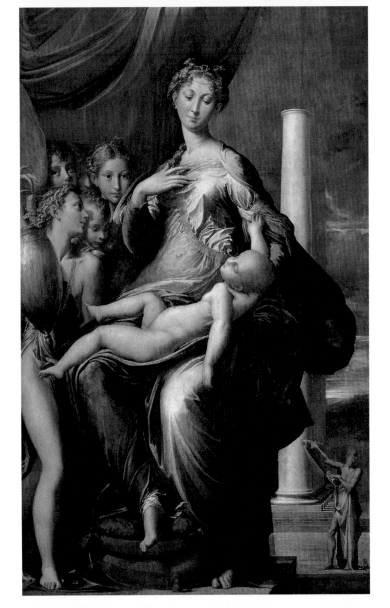

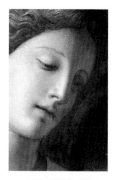

The golden background of the mosaic symbolizes the heavens, a custom adopted from the ancient pagan religions.

Duccio's Madonna is no less beautiful, seated on an elaborate throne. Although *Our Lady and Her Child* appear to be three-dimensional and realistic, the surrounding environment is stylized, disregarding the principles of perspective.

The Holy Family

Agnolo Bronzino, c.1540
oil on wood, 117 x 93 cm
Uffizi, Florence

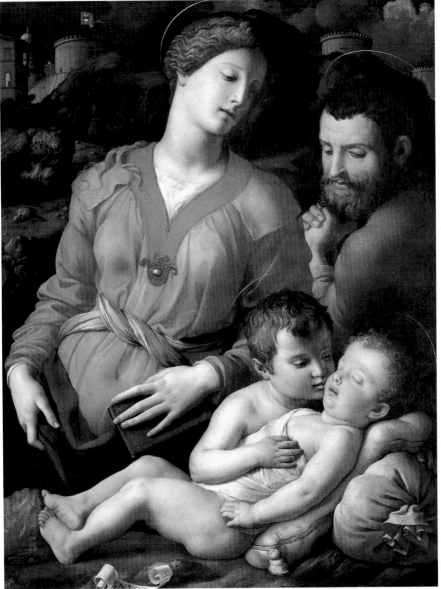

107

Hierarchic scale, often used in medieval times, is featured, depicting the most important subject – Mary – as the largest. The symmetrical distribution of the six angels, three on each side of the Madonna, may be symbolic of the order that Mary, as Mother Church, imposes on her subjects. Yet above all she remains the loving mother.

The Immaculate Conception

Giorgio Vasari, 1541
oil on wood, 58 x 40 cm
Uffizi, Florence

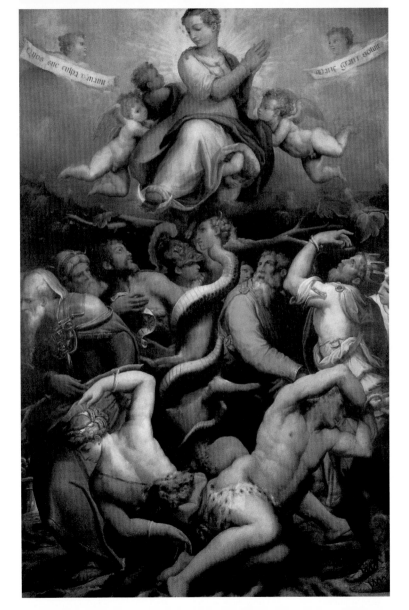

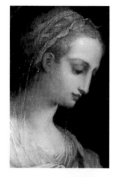

The compassionate and loving nature of Mary the Mother of God and of Christians worldwide is perhaps most clearly expressed by the artists who formulated the motif of the Madonna of the Misericordia. One such Madonna was created by Simone Martini during the thirteenth century. Martini painted the Virgin as a powerful but compassionate figure, encased in a capacious mantle which is used to accommodate scores of people.

## The Annunciation

Giorgio Vasari, 1564-1567
oil on wood, 216 x 166 cm
The Louvre, Paris

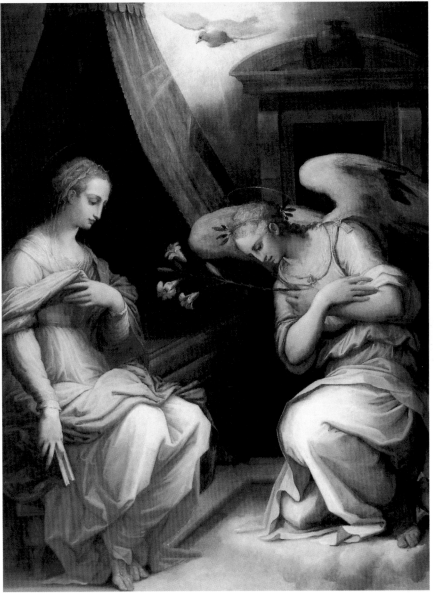

The people involved appear to be mostly royalty, nobility and clergy. This image of Madonna embodies the desire of humanity to be fully protected and loved by the Divine Mother of the World.

The theme of the Annunciation was emphasized during the Middle Ages to the point of stylizing this important event in Mary's life: the prediction of her miraculous pregnancy.

The Holy Family with Saint Barbara and the Young Saint John the Baptist

Paolo Veronese, 1564
oil on canvas, 86 x 122 cm
Uffizi, Florence

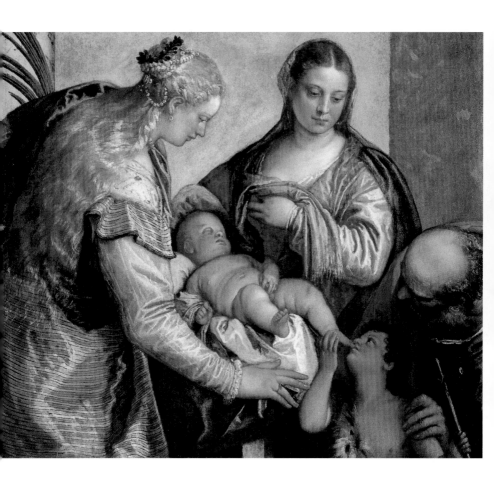

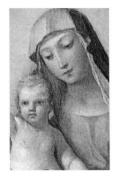

Simone Martini and Lippo Memmi painted *The Annunciation, with Saints Ansanus and Margaret and Four Prophets* for the altar of Sant' Ansano inside Siena Cathedral in 1333. The Virgin is seated before a solid gold background that is symbolic of spirituality, while the Archangel Gabriel kneels in front of her. A vase nearby contains lilies, symbols of the Virgin's purity and her Immaculate Conception.

The Virgin Appearing to Saint Luke and Saint Catherine

Annibale Carracci, 1592
oil on canvas, 401 x 226 cm
The Louvre, Paris

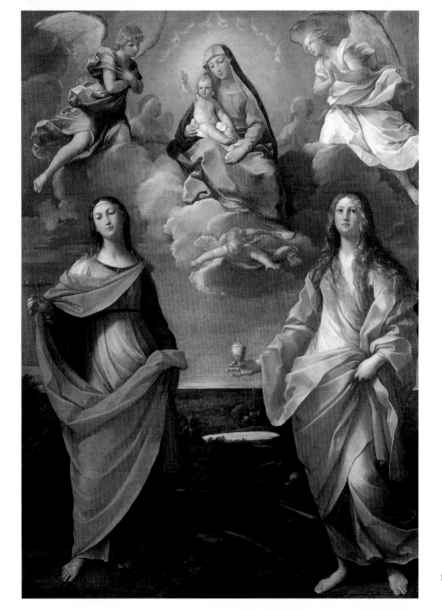

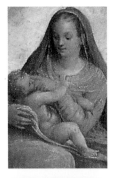

Above, Gothic arches accommodate several angels and prophets, while the side panels contain standing figures of St Ansanus and St Margaret.

The theme of the Virgin and Child was popular in both Eastern and Western Europe during the Middle Ages. The Eastern icon style, including that of Russia's artists, has changed little throughout the centuries, remaining stylized and abstract.

The Consecration to the Virgin

Lavinia Fontana, 1599
oil on canvas, 280 x 186 cm
Musée des Beaux-Arts, Marseille

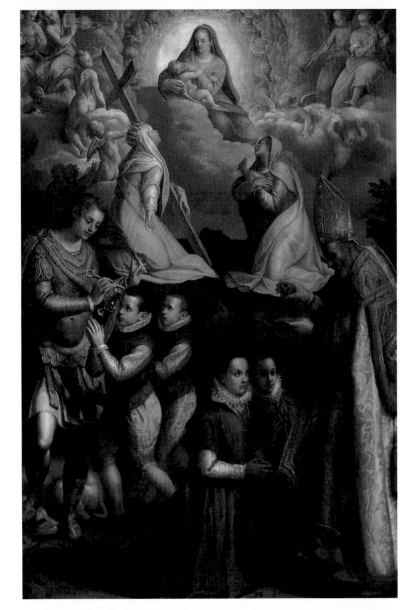

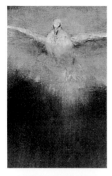

During the fourteenth century, Italy produced a large number of paintings of the Madonna. The work by Lorenzo Veneziano shows the Virgin and Child enthroned, a traditional theme that was to flourish later during the Renaissance and the Baroque periods. This Madonna has more realistic, softer features, and seems to gaze at the viewer, while the infant's attention is centred on her.

Pentecost

El Greco, c.1600
oil on canvas, 275 x 127 cm
Prado Museum, Madrid

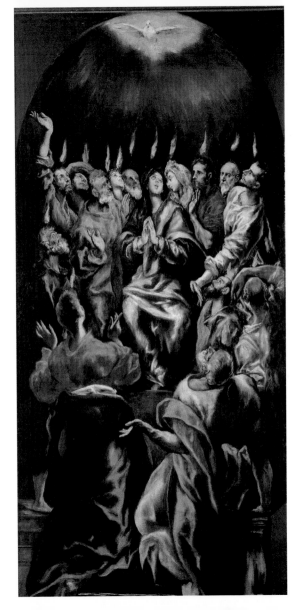

The two share an intimate bond. Both are holding a rose, symbol of female divinity and spirituality. Mary's ornate throne is a metaphor for the Church. She is both the Great Mother and the Mother Church of her people. The sun-shaped halo and the stars around her head attest to her also being the Queen of Heaven.

Annunciation of the Birth of Mary

Bernardino Luini, early XVIth-century
Pinacoteca di Brera, Milan

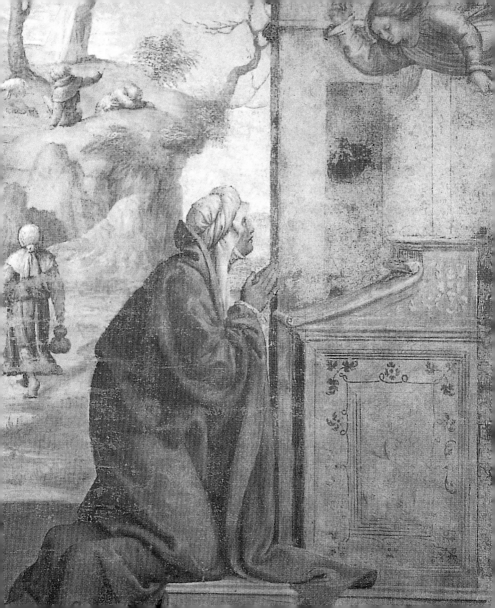

Luca Signorelli's tondo, painted perhaps a couple of decades later, depicts the Madonna and her nude child in the foreground, her head turned toward him. A halo barely visible over her head reminds the viewer of her holiness, while the physical beauty of the infant emphasizes the subject of incarnation. In the background an outdoor scene contains several nude or seminude young males.

The Virgin in Sadness

Quentin Matsys
Rainado da Costro, Coimbra (Spain)

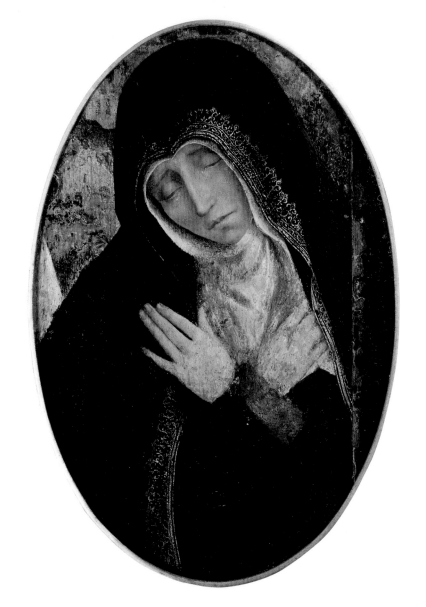

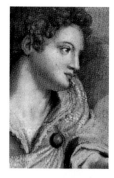

They suggest the exuberance of young male flesh, and predict the future of Christ as an incarnate godlike male.

Jacobello painted an image of the Mother, titled *Madonna of the Misericordia*, at the end of the fourteenth century. Toward the top of the painting we can see the two protagonists of the Annunciation. The figure of Mary is on the right, her arms crossed in a gesture of acceptance of her destiny.

The Annunciation
_____

Alessandro Allori, 1603
oil on canvas, 162 x 103 cm
Galleria dell'Accademia, Florence

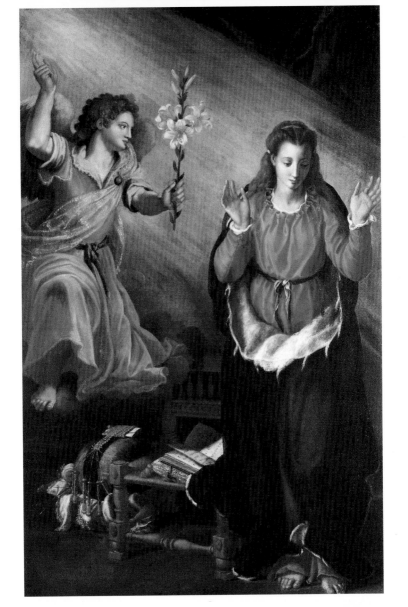

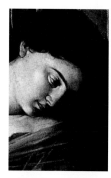

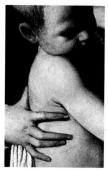

On the left, the archangel Gabriel is shown holding the lilies that symbolize the purity of the Immaculate Conception of Mary. Mary is the compassionate and loving Great Mother-Protectress of the people.

Another version of the Madonna had been created by Masolino and Masaccio shortly after 1426. This tempera painting, titled *St Anne Metterza*, features the enthroned Madonna with her son Jesus on her lap.

Madonna di Loreto
(Madonna dei pellegrini)

Caravaggio, 1603-1606
oil on canvas, 260 x 150 cm
Church of Sant'Agostino, Rome

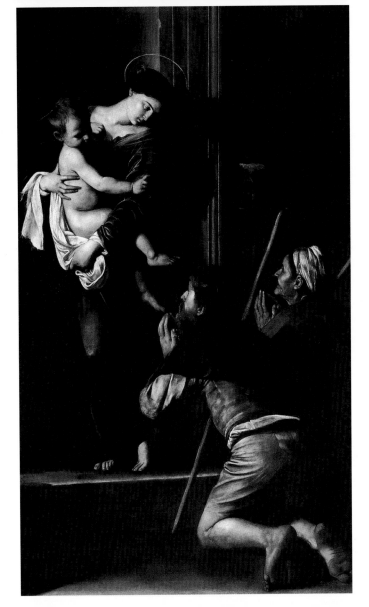

Directly behind her stands the imposing figure of her mother, St Anne. They are surrounded by adoring angels. This image is reminiscent of the ancient mother and daughter goddesses. The Mother Goddess Demeter and her daughter Persephone were worshipped in antiquity by the Greeks as divine creators and nurturers of the natural cycle. Ancient images of natural deities were often portrayed in groups of three, and in some cases the third divinity – an infant – was a male.

### The Madonna and Child

Artemisia Gentileschi, c.1609
oil on canvas,
Spada Gallery, Rome

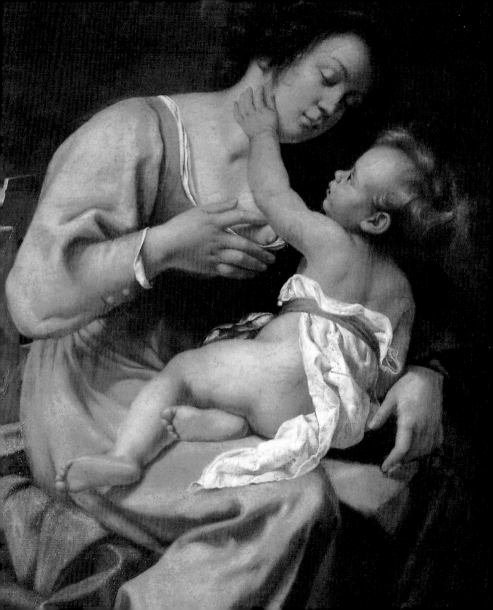

St Luke the Apostle, who is the accredited author of one of the four accepted versions of the New Testament Gospel, is also by tradition the first painter of the Virgin's portrait. Rogier van der Weyden kept up this tradition in his own picture of *St Luke Painting the Virgin* of 1450. This meticulously detailed work shows Mary seated under a canopy as she attempts to nurse her infant, and Luke in front of her, sketching her face.

## The Madonna of the Basket

Peter Paul Rubens, c.1615
oil on canvas, 114 x 88 cm
Pitti Palace Gallery, Florence

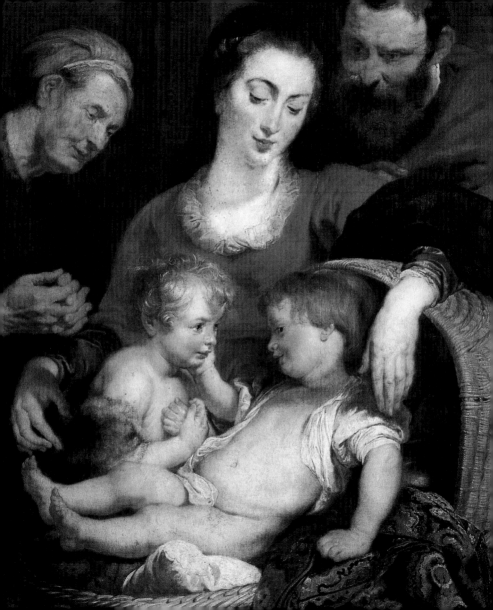

Nursing Madonna images had been part of the Marian tradition and lore since the Middle Ages. "Mary's milk" had, indeed, been a source of veneration in the form of a miracle-working substance. The origins of such a tradition and symbolism go back several thousands of years into antiquity, when Creator Goddesses like Isis were celebrated as symbolic milk-givers in their roles as compassionate and nurturing Universal Mothers.

The Adoration of the Child

Correggio, 1524-1526
oil on canvas, 81 x 77 cm
Uffizi, Florence

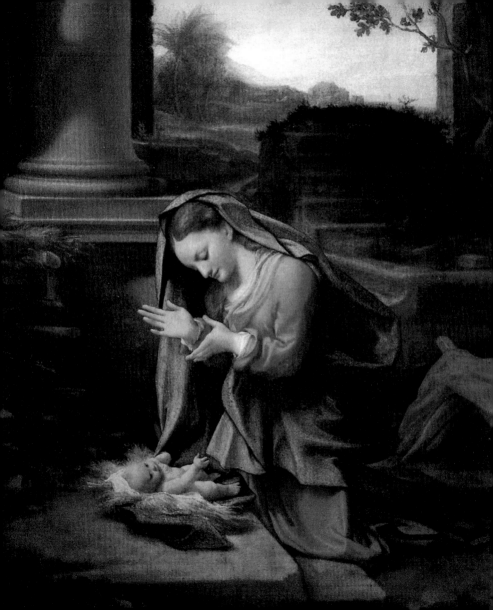

The milky ribbon of stars called the Milky Way was believed to symbolize the Goddess, and Marian lore inherited that popular tradition.

Benozzo Gozzoli painted *Madonna della Cintola*, in tempera on wood in around 1450-1452. It shows Mary enthroned, having ascended into the sky over several bluish cumulus clouds.

## The Rest on the Flight into Egypt

Giovanni Battista Caracciolo, 1618
oil on canvas, 205 x 186 cm
Uffizi, Florence

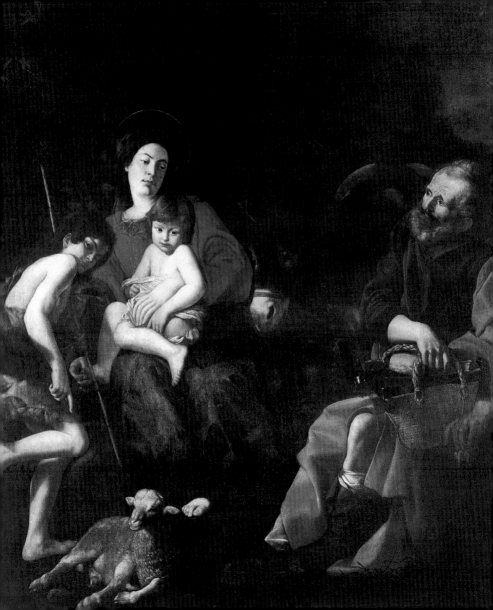

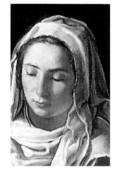

She is dressed in a blue cape, symbolic of her status as the Queen of Heaven, and is surrounded by a large golden nimbus. Several adoring angels cluster near her, including one playing a musical instrument. The cintola or sash has been passed by her to an angel who is letting it fall toward the ground and into the hands of St Thomas, kneeling on the ground beneath. In this way any doubts he might have had about the Assumption of the Virgin are completely eliminated.

## The Adoration of the Magi

Diego Velásquez, 1619
oil on canvas, 203 x 125 cm
Prado Museum, Madrid

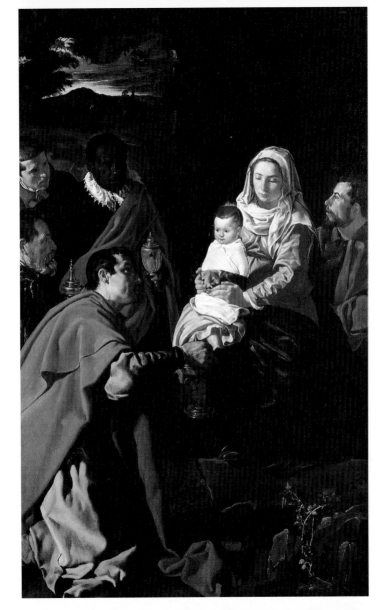

137

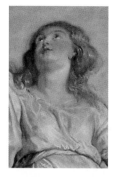

Fra Filippo Lippi created his *Madonna and Child with Stories of the Life of St Anne* in 1452. This painting is also a celebration of Mary's own birth. The background scenes are dedicated to the Virgin's mother, St Anne, and include the first meeting of Anne and her husband-to-be Joachim, and a scene of the subsequent birth of Mary. In the foreground is the Madonna with her child.

The Assumption of the Virgin

Peter Paul Rubens, c.1620
oil on canvas, 458 x 297 cm
Kunsthistorisches Museum, Vienna

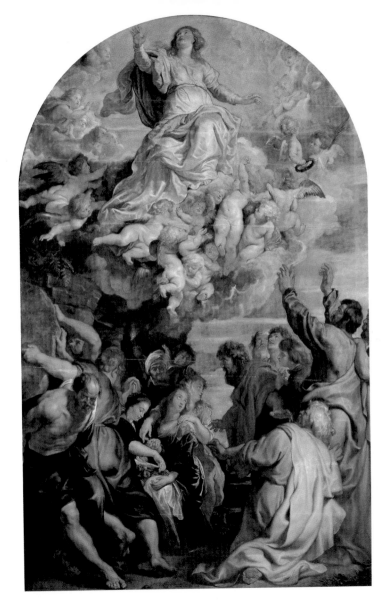

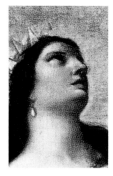

Like Persephone, the Greek goddess of the natural cycle, she is holding a pomegranate, a symbol of rebirth, fertility, and abundance in nature.

Like the death of her son, Mary's death is surrounded by special circumstances. Some earlier versions like Jean Fouquet's *La Mort de la Vierge*, of the late fifteenth century concentrate on the part of the story that describes her son and "bridegroom" taking her soul, in the form of a child, up to heaven.

The Three Magdalenes

Andrea Sacchi, 1628-1639
oil and tempera on canvas, 287 x 197 cm
Uffizi, Florence

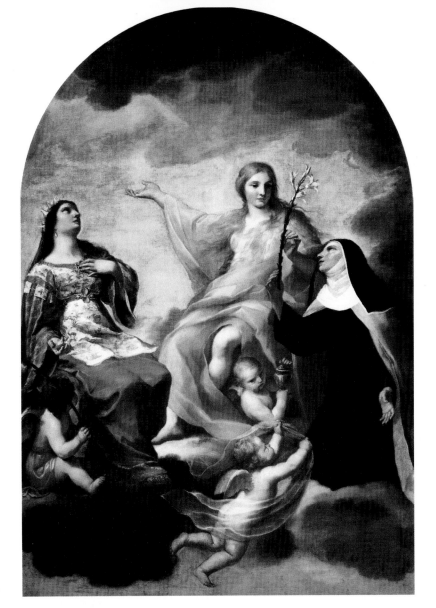

The reclining body of the "sleeping" Virgin is surrounded by the patriarchs. Above, the figure of Jesus, surrounded by light, holds the Holy Virgin as an infant, a role-reversal. This image shows a patristic version of the doctrine by which Mary, the exceptional female, is truly unique of all her sex.

Leonardo da Vinci's *The Annunciation*, painted around 1470, is one of the most popular versions of this subject.

### The Annunciation

Simon Vouet, 1632
oil on canvas, 230 x 159 cm
The Pushkin Museum of Fine Arts, Moscow

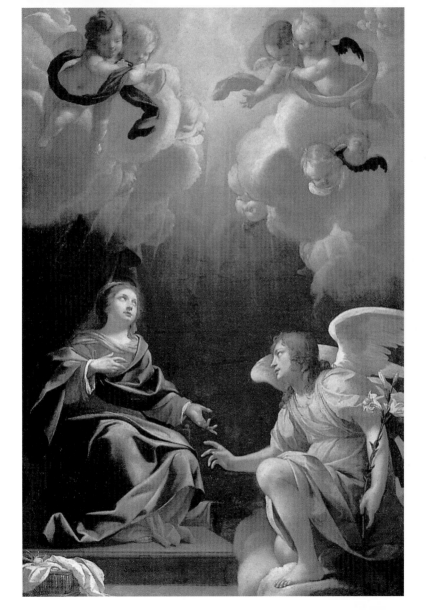

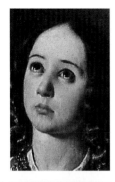

The angel, carrying white lilies, kneels to the Madonna. They both represent ideal beauty and exuberance of youth. The Virgin's right hand is resting on the page of a book, symbolic of her knowledge as Mary-Sophia, the personification both of Wisdom and of the Logos, the Word of God. Below her hand, the shell that adorns the furniture represents the connection between Mary and the ancient Roman goddess of love, Venus.

The Immaculate Conception

Francisco de Zurbarán, 1632
oil on canvas, 252 x 170 cm
Museo del Arte Catalana, Barcelona

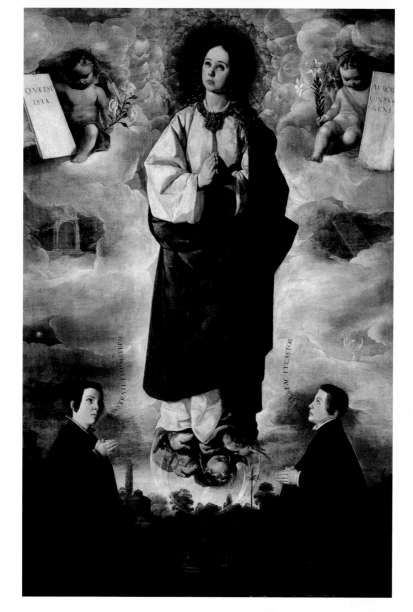

*The Assumption of the Virgin,* by Matteo di Giovanni, executed sometime in the late fifteenth century relates the story of Mary's bodily translation into heaven. This issue became an important part of the Christian doctrine because it was obvious to the Church authorities that a Mother of God who was herself perfect was the only figure with enough dignity to give birth to the Savior of the world.

The Holy Family with Angels

———————————————————

Rembrandt, c.1645
oil on canvas, 117 x 91 cm
The Hermitage, St. Petersburg

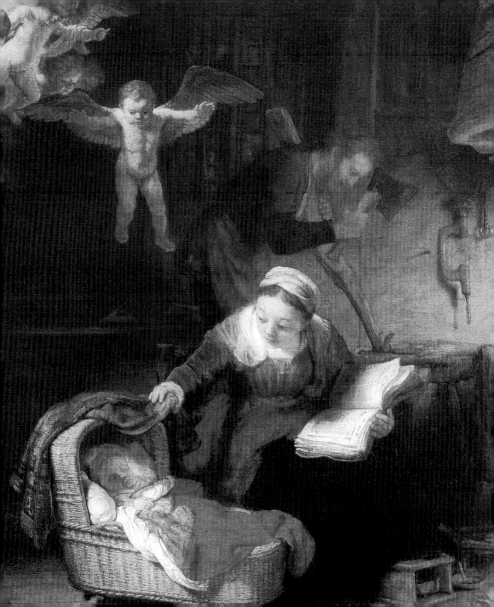

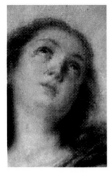

The notion that her body, like that of Jesus, ascended to heaven together with her soul seemed the only way to prove the point of her purity.

The paintings of the Virgin by Botticelli, dated between 1481 and 1485, may embody the purest essence of the physical ideal, in relation to both the Madonna and the baby Jesus, developed during the Renaissance.

La Immaculada de Aranjuéz

Bartolomé Estebán Murillo, 1650-1660
oil on canvas, 222 x 118 cm
Prado Museum, Madrid

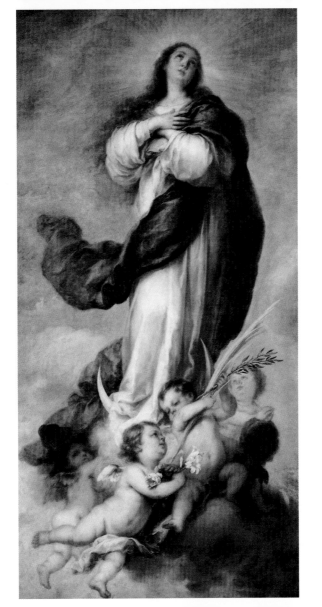

At the same time, a deep sense of spirituality pervades the scene, *Madonna and Child with Angels*, painted in tempera on a wooden panel.

Lorenzo di Credi depicts Mary standing in front of the kneeling and adoring archangel in his painting titled *The Annunciation*. Mary's face is serene. The garden, seen through the three arches, alludes to the Holy Trinity and complements the physical beauty of the two figures.

## The Madonna and Child

Bartolomé Estebán Murillo, c.1650
oil on canvas, 155 x 107 cm
Pitti Palace Gallery, Florence

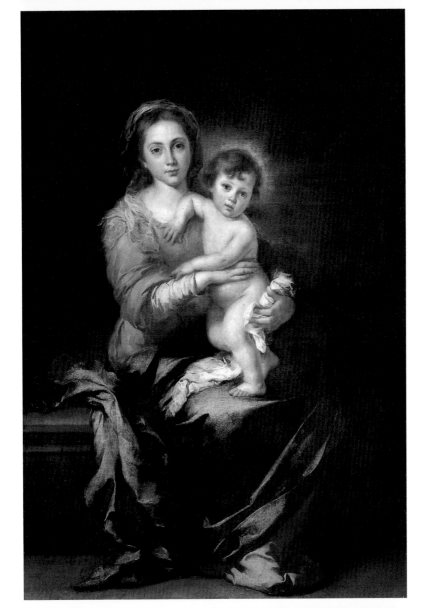

At the bottom of the painting, a relief shows Adam and Eve and their Fall from the Garden of Eden. Here, Mary is thus also the new Eve, the co-redeemer of humanity.

The tondo painted by Francesco Botticini in about 1482, shows a great deal of concern for details – a Flemish influence. Botticini depicts Mary as seated in the center of the composition, the infant Jesus lying at her feet. She represents the Renaissance ideal of physical perfection, and is shown adoring her own Son.

## The Adoration of the Magi

Bartolomé Esteban Murillo, 1655-1660
oil on canvas, 190 x 146 cm
Museum of Art, Toledo (Ohio, USA)

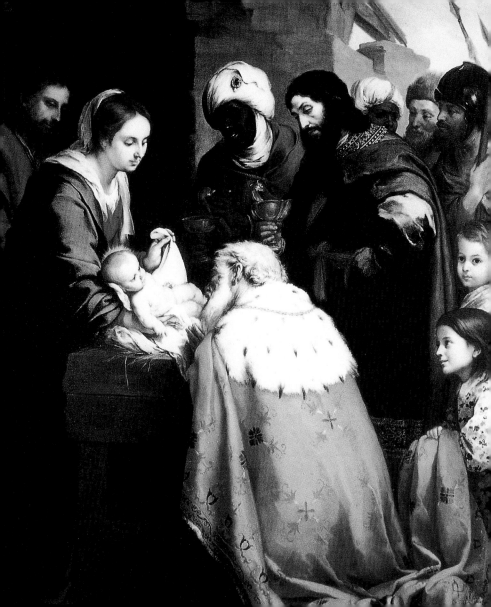

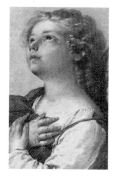

*The Virgin of the Rocks*, c.1493, by Leonardo da Vinci, is probably the most well-known painting of the Virgin and Child within the Western world. This work is one of the best examples of the use of atmospheric perspective and the correct foreshortening of the human figure. The figure of the Madonna occupies the apex of the pyramid-based composition of this painting due to her high ranking within contemporary Christian belief.

Saint Anne and the Infant Mary
_____

Luca Giordano, 1657
oil on canvas, 341 x 249 cm
Chiesa dell'Ascensione a Chiaia, Naples

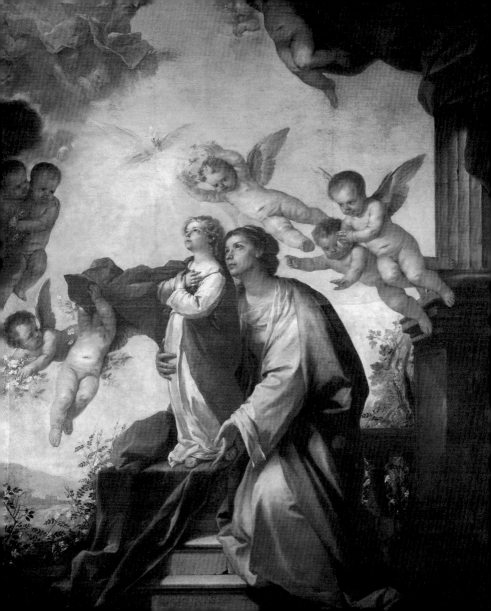

She is accompanied by the infants Jesus and St John, and an angel, perhaps female. All four reflect the Renaissance ideal of the human form. Renaissance artists were enchanted with the rediscovery of pagan beliefs and with the connections that could be made between Christian and Greco-Roman symbolism. Sandro Botticelli painted *The Birth of Venus* in around 1486.

## The Annunciation

Bartolomé Esteban Murillo, 1660-1665
oil on canvas, 142 x 107.5 cm
Prado Museum, Madrid

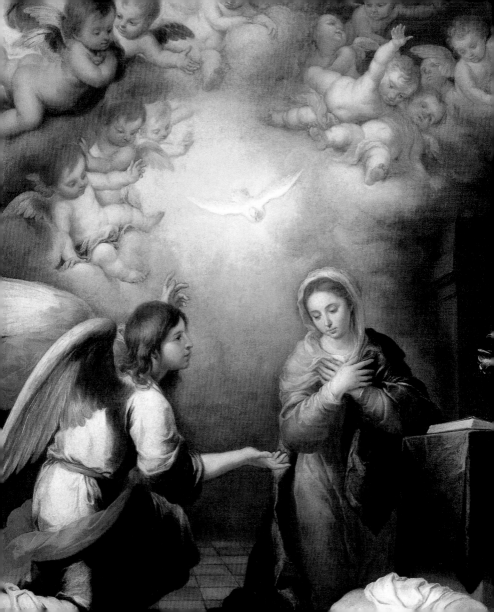

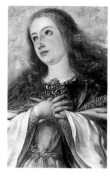

The goddess closely resembles Mary. The message of the all-embracing love of the Venus/Mary becomes all-inclusive: she is the source of all aspects of love, the heavenly and the earthly.

The Renaissance Madonna was frequently turned into an advocate for the dominant establishment and the patriarchal Church. Her unique virgin birth separated her from ordinary women.

La Immaculada

Juan Valdes Leal, 1661
oil of canvas, 190 x 204 cm
National Gallery, London

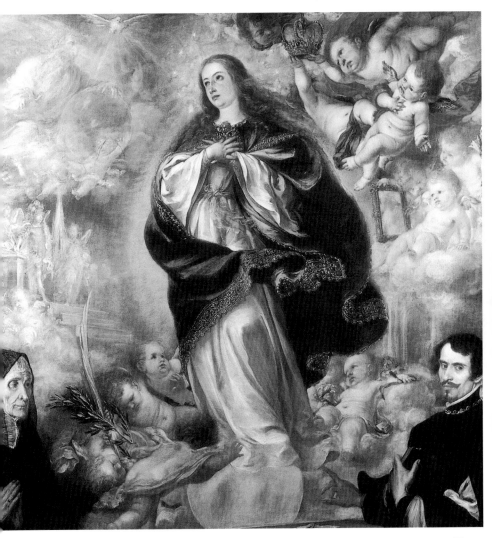

The iconography of the Virgin often shows her surrounded exclusively by males: Jesus, angels, and saints. Furthermore, the acceptance in art of the aging process in men, but not in women, also played an important role in devaluing the female gender. Filippino Lippi uses this traditional approach in his *Madonna and Child Enthroned with Saints John the Baptist, Victor, Bernard, and Zenobius*, a painting completed in 1486.

## The Flight into Egypt

Bartolomé Estebán Murillo, 1670-1675
Oil on canvas, 101 x 62 cm
The Pushkin Museum of Fine Arts, Moscow

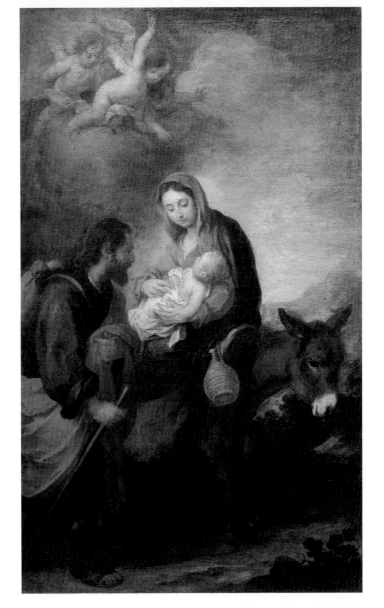

In another painting by Botticelli, also titled *Madonna and Child with Angels,* or *Madonna of the Pomegranate,* the Virgin is the focal center of the composition, and is seated with the infant stretched out on her lap. She is surrounded by angels who carry flowers, symbols of Mary's perfection and purity, and books, symbols of her wisdom. The child is holding the pomegranate, an allusion to the fertility and the generative power of the goddess.

The Madonna Appearing to Saint Philip Neri

Carlo Maratta, 1672
oil on canvas, 197 x 343 cm
Uffizi, Florence

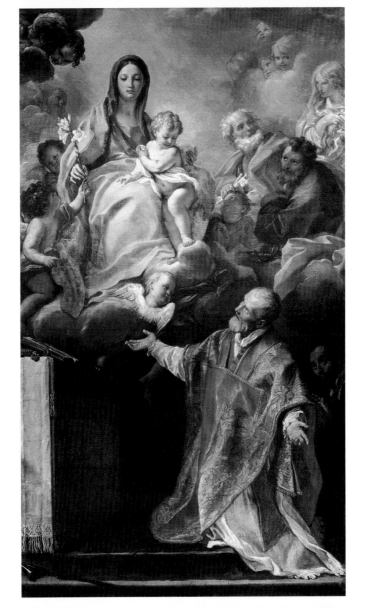

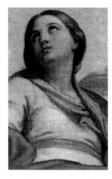

In *The Annunciation* by Sandro Botticelli, painted in 1489, Mary – a woman of perfect beauty – is shown expressively gesturing at the fervent but submissive archangel Gabriel, who bears white lilies to symbolize the purity and perfection of the Virgin.

*The Madonna of the Caves* was completed by Andrea Mantegna toward the end of the fifteenth century. The seated figure of Mary is surrounded by a rocky landscape.

## The Immaculate Conception

Carlo Maratta, 1686
oil on canvas, 300 x 240 cm
Church of Santa Maria del Popolo, Rome

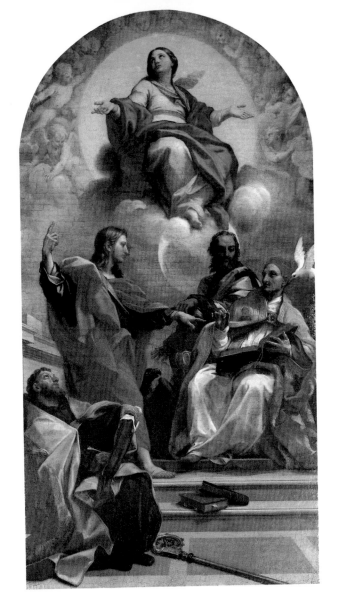

Her pensive gaze is fixed on her child, postionned facing forward on her knee. Behind them, a view of a harvesting scene can be observed. As in medieval times, during the Renaissance Mary assumed the role of the Madonna of the Grain or the Madonna of the Harvests, or the Mother of Nature. This aspect connects her to a number of ancient goddesses, such as Demeter or Juno, two of the goddesses connected to agriculture and worshipped as the donors of bountiful crop harvests.

### The Marriage of the Virgin

Luca Giordano, c.1688
oil on canvas, 115 x 135 cm
The Louvre, Paris

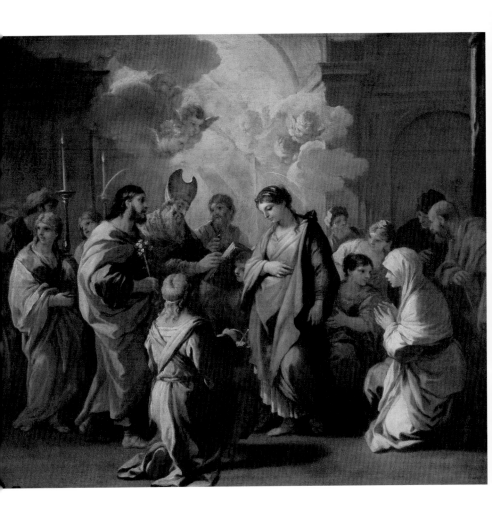

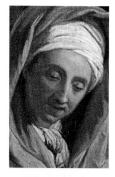

Hans Memling painted his *Madonna and Child with Two Angels* during the second half of the fifteenth century. The Virgin and her child are seated on a throne amid lavish surroundings. Golden rays emanate from the Queen of Heaven's head, and the two musical angels are eager to entertain her son.

Another event in Mary's life often interpreted by artists is usually named The Visitation.

## The Education of the Virgin

Jean Jouvenet, c.1700
oil on canvas, 102 x 71 cm
Uffizi, Florence

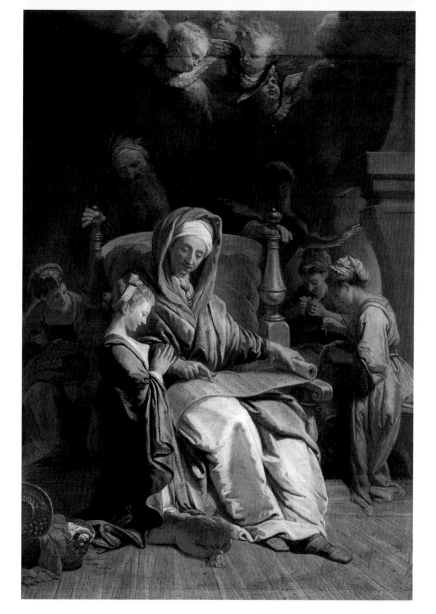

Mary, while pregnant with Jesus, visits her cousin Elizabeth who is more heavily pregnant with the child who is to be John the Baptist. Elizabeth, realizing the importance of Mary's pregnancy, is portrayed either kneeling in front of Mary or showing her delight by closely embracing her. Domenico Ghirlandaio executed his version of *The Visitation* in 1491. Elizabeth kneels before Mary, whose teenage face is beautiful and calm. It is a scene of tenderness and emotion, of bonding between women.

Mater Dolorosa

Bartolomé Esteban Murillo, XVIIth century
Prado Museum, Madrid

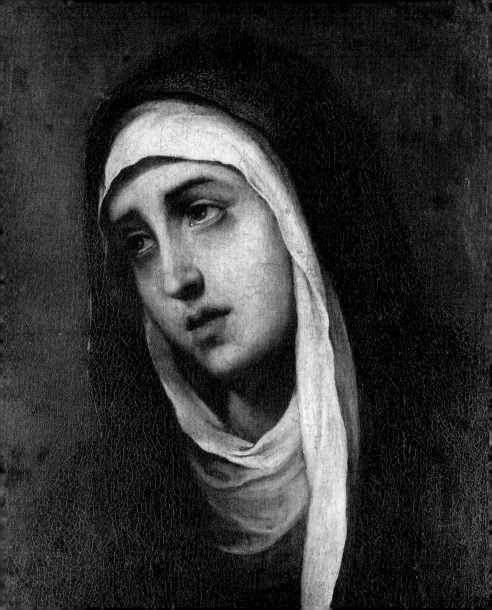

*The Virgin and Child Accompanied by Two Angels, St Rose and St Catherine* is a wood tondo painted by Perugino toward the end of the fifteenth century. The artist has presented a feminine point of view on the subject of the enthroned Madonna. The Virgin, an image of physical perfection, is earthbound. Two angels stand directly behind the Madonna.

The Immaculate Conception

Antonio de Pereda, mid-XVIIth century
oil on canvas
Museé des Beaux-Arts, Lyon

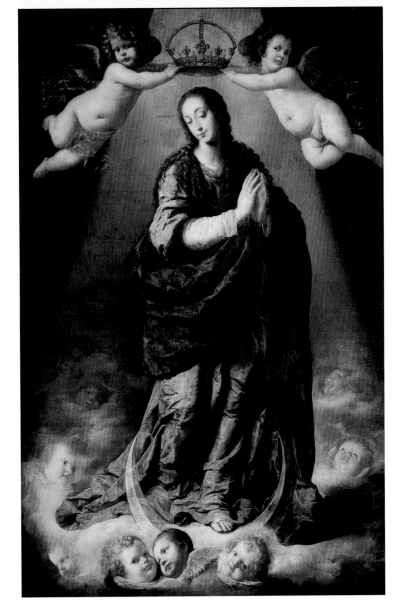

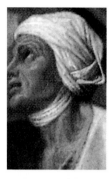

The angels, usually portrayed as male according to the customary Renaissance iconography, appear on this occasion to be two beautiful young women. On each side of the Madonna stand the figures of St Rose and St Catherine; together they form a female spiritual trinity. The scene's symmetrical composition implies unity and balance.

The Holy Family in a Landscape

Nicolas Poussin, mid-XVIIth century
oil on canvas, 94 x 122 cm
The Louvre, Paris

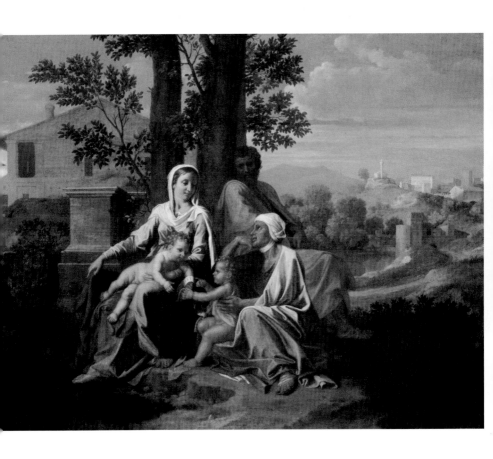

The theme of the event of Mary's childhood life painted by Nicolas Dipre is her visit to the Temple in Jerusalem. *The Presentation of the Virgin at the Temple* was executed c.1500. It depicts Mary as a child, climbing the steps that lead toward the patriarch on the throne, watched by her parents, St Anne and St Joachim. Her mother is gazing at her daughter, while her father is holding a small lamb, a symbol of Jesus, Mary's future Son.

The Adoration of the Shepherds

Adriaen van der Werff, 1703
oil on wood, 53 x 36 cm
Uffizi, Florence

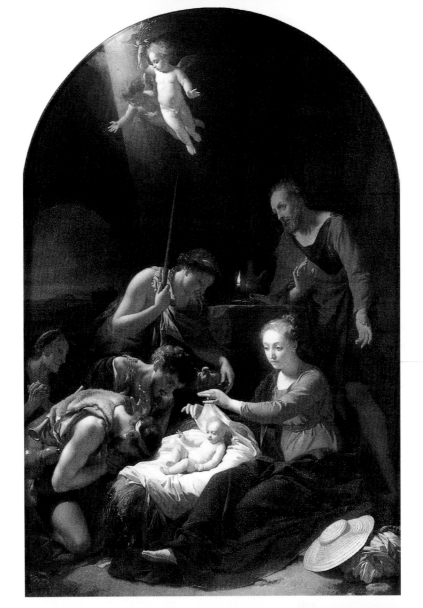

177

Mariotto Albertinelli's *The Visitation* depicts the figures of both Mary and Elizabeth in front of an open sky-filled arch, their right hands are held together. It is a tender moment, showing the two women's appreciation of each other.

*The Holy Family with the Young St John the Baptist*, also called the *Doni Tondo*, was painted by Michelangelo. The fact that this work was not created for a church might explain Michelangelo's apparent freedom to place several young male nudes in the background, behind the little figure of St John.

The Rest on the Flight into Egypt

Antoine Watteau, 1719-1721
oil on canvas, 129 x 98 cm
The Hermitage, St. Petersburg

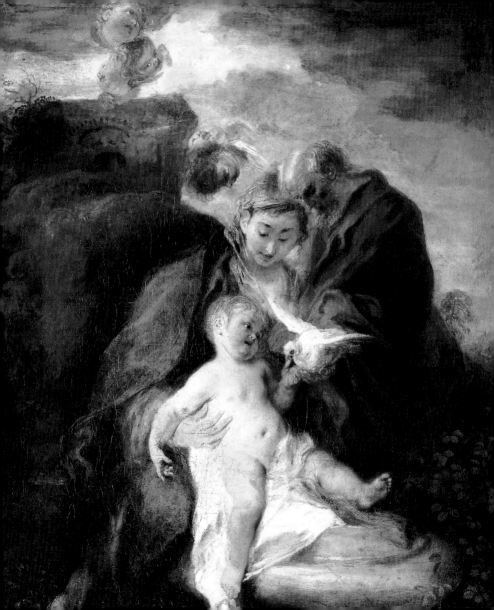

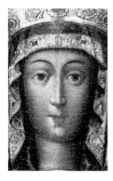

The young, strong and elegantly poised figure of Mary, holding her infant up on her shoulder, is contrasted with the figure of Joseph, who is depicted subject to the ravages of old age. The child, like the mother, is active and full of life. This is another work in which Mary and Jesus appear to be fully human.

A large oil painting, completed at the beginning of the sixteenth century by Piero di Cosimo, titled *The Immaculate Conception and Six Saints*, depicts the Madonna, standing on a platform in her glory.

The Virgin of the Sign

Anonymous, 1732
Church of the Transfiguration
Bolshye Sarachints (Poltava, Ukraine)

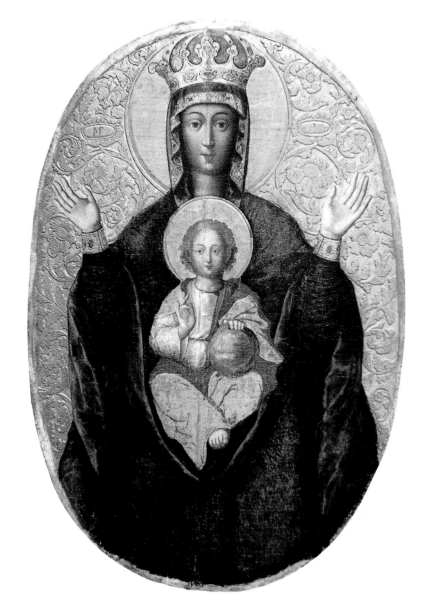

Above her the clouds in the sky have parted, letting the light from above descend upon her, with the symbol for the Holy Spirit, in the form of a dove, hovering over her head. Since the very beginning of Christianity, the Holy Spirit and Mary have been accorded a very close relationship, according to popular lore. Below, on the pedestal, a relief on the theme of the Annunciation is clearly visible. Mary's gaze is directed toward the holy dove, while the saints appear in postures of adoration.

## Madonna and Child

Pompeo Batoni, c.1742
oil on canvas
Galleria Borghese, Rome

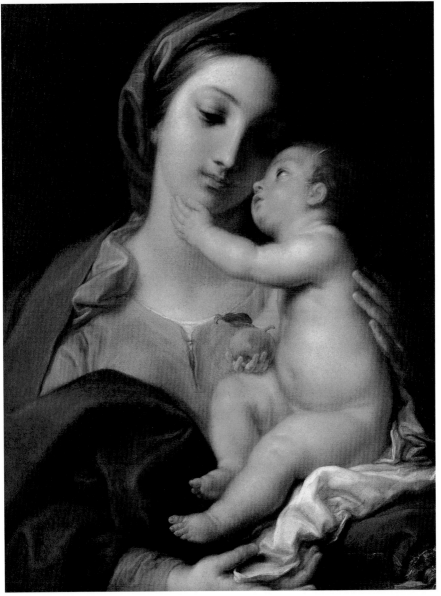

183

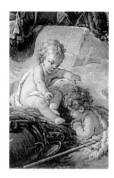

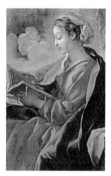

On his painting *Madonna of the Goldfinch* Raphael painted the figure of the Madonna in the center, using the standard pyramidal design for the composition. In her left hand Mary holds a book, while her right arm encloses the child Jesus, whose small hands enfold the goldfinch. The infant St John endeavors to caress the bird. Mary and Jesus have barely visible haloes over their heads, rendered in perspective, in order not to disturb the realism of the style employed.

## The Rest on the Flight into Egypt

François Boucher, 1757
oil on canvas, 139.5 x 148.5 cm
The Hermitage, St. Petersburg

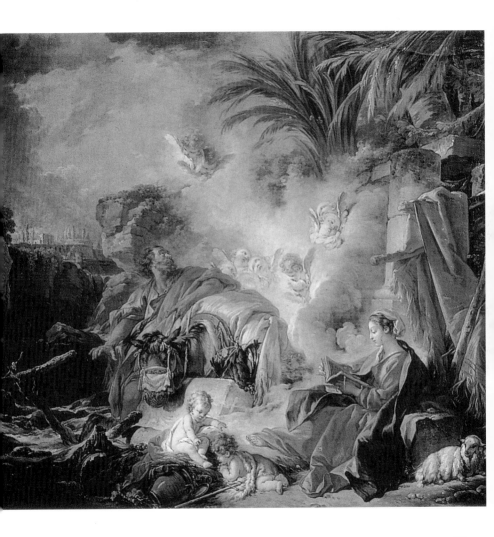

*La Belle Jardinière,* or *The Virgin and Child with the Infant St John the Baptist in a Landscape* is another painting by Raphael. The similarity between the Madonna of the Goldfinch and this depiction of the Madonna is more than coincidental: it represents the ideal of female beauty according to Raphael. Perhaps the same model was used in both paintings.

The Madonna with the
Infant Jesus and the little Saint John

François Boucher, 1758
oil on canvas, 118 x 90 cm
Pushkin Museum of Fine Arts, Moscow

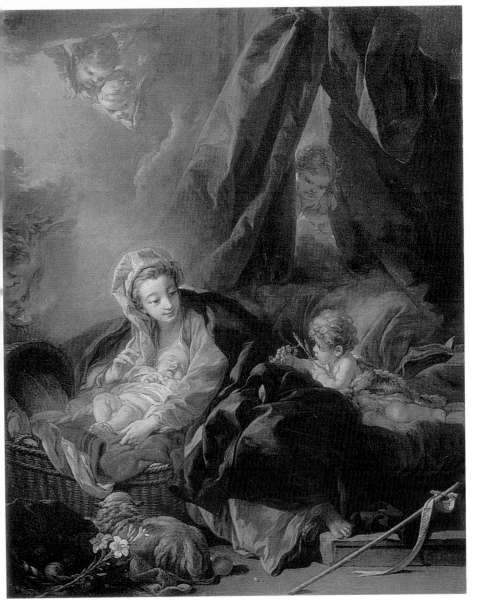

*The Madonna of the Baldacchino* by Raphael is an example of the Holy Virgin enthroned and surrounded by males of various ages, from early childhood to advanced old age. Two active teenage angels hover above the Madonna and her Child, ensconced in the center of the painting. Mary is very young, and an ideal of beauty for every Renaissance woman to emulate. Although surrounded by queenly luxury, she looks modest and unpretentious. Her attention is focused on her infant who gazes at the two saints.

Saint Roch Praying to the
Virgin to Cure the Plague-Carriers

Jacques-Louis David, 1780
oil on canvas, 260 x 195 cm
Musée des Beaux-Arts, Marseille

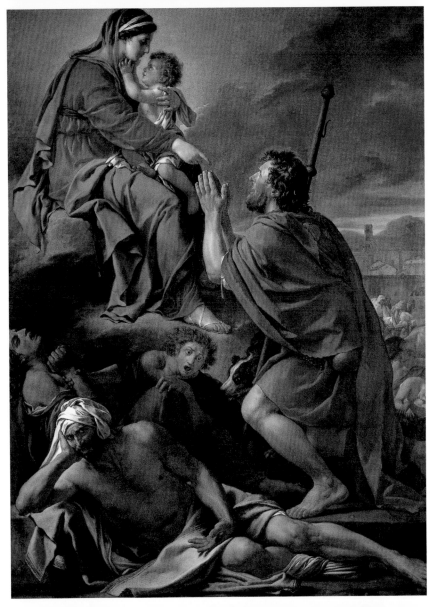

189

In Sebastiano del Piombo's version of *The Visitation* Mary and Elizabeth are shown in front of a landscape. These lively figures appear to be conversing: the older woman, Elizabeth, gazes with admiration at Mary. The Virgin has extended her arm toward Elizabeth's shoulder, a gesture of embrace. The artist focuses on the rapport and the spiritual connection between the two women.

The Immaculate

———————

Gian Battista Piazzetta
first half of the XVIIIth century
oil on canvas
Pinacoteca, Parma

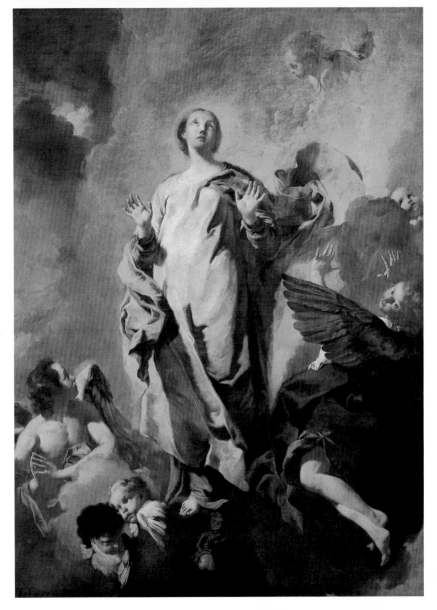

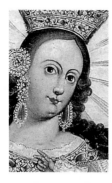

Another painting of Leonardo da Vinci is titled *The Virgin and Child with St Anne*. Mary is seated on St Anne's lap and is holding onto her child who is playing with a small lamb, a symbol of Jesus as the redeemer. Jesus's gaze is directed at his mother. St Anne, pensive, also looks tenderly at her daughter Mary. They are surrounded by a landscape, and seem more human than divine. This painting speaks of a bond between mother and daughter.

The Virgin of the Rosary of Pomato

Anonymous, School of Cuzco, XVIIIth century
oil on canvas
Convent of Santa Catalina, Cuzco (Peru)

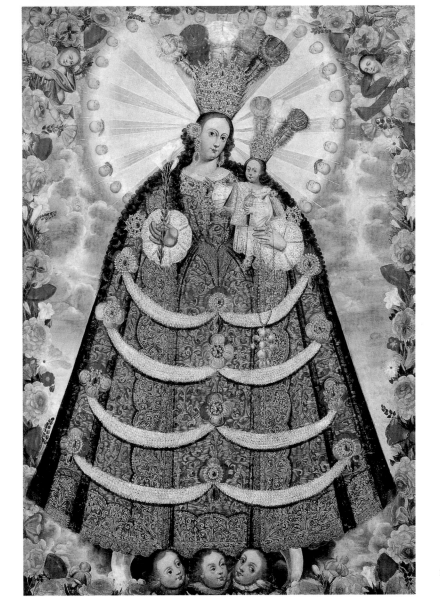

193

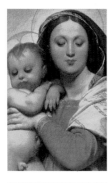

Raphael painted a tondo known as the *Madonna of the Chair*. In this work, the seated Mary holds her infant on her lap while St John, an older child, gazes at them both in adoration, his little hands cupped together in a gesture of reverence. The emotional connection between the Virgin and her child is obvious, her head leaning against his. But her beautiful eyes look also back at the viewers of the picture.

Le Vœu de Louis XIII

Jean-Auguste-Dominique Ingres, 1824
oil on canvas, 421 x 262 cm
Cathedral of Notre-Dame, Montauban (France)

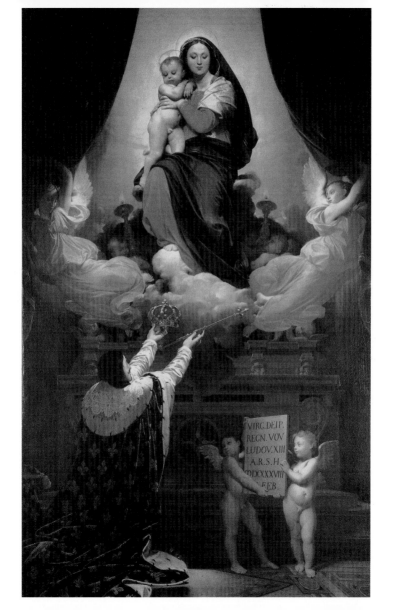

VIRG. DEI P.
REGN. VOV.
LUDOV. XIII
A.R.S.H.
DIXXXXVIII
FEB.

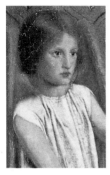

Painted by Andrea del Sarto in 1518, the *Panciatichi Assumption* depicts a group of male saints who represent witnesses to the event as they crowd around the now-vacant dais from which the Madonna has risen up into the heavenly realm. Above, seated on cumulus clouds and surrounded by a group of cherubim, is the Queen of Heaven, her eyes cast upward in anticipation of a reunion with her Son.

## The Childhood of Mary

Dante Gabriel Rossetti, 1848-1849
oil on canvas, 83.2 x 65.4 cm
Tate Gallery, London

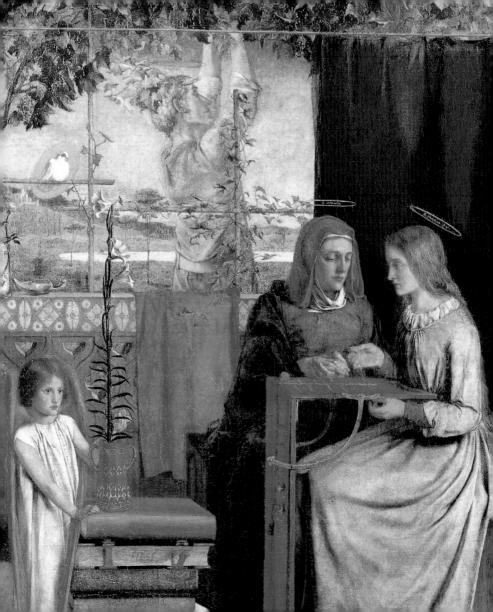

Dosso Dossi painted the Virgin in the third decade of the fifteenth century in a piece titled *Madonna in Glory with Saints John the Baptist and John the Evangelist.* The Madonna and her infant appear above the standing figures of the saints, among the clouds. Below, St John the Evangelist holds up a chalice that has a snake arising out of it towards her. The chalice, in Christianity the mysterious Holy Grail, is also the universal symbol for the divine female principle, and the serpent is another symbol associated with female gods.

### Ecce Ancilla Domini

Dante Gabriel Rossetti, 1849-1850
oil on canvas, 73 x 42 cm
Tate Gallery, London

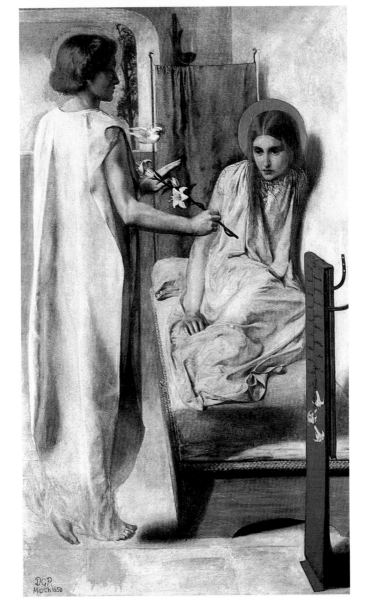

*Pietà with Saints (the Pietà of Luco)* by Andrea del Sarto was completed in 1523. The artist placed the figure of Mary as the grieving mother in the center of his composition, next to the dead body of Christ. Two young female saints are at her side, one of whom is Mary Magdalene, also often seen as the "beloved of Christ", his bride or spouse. Magdalene persists as a controversial as well as a popular figure within Christianity. The third female saint is considered to be another Mary, thus forming the holy female trinity.

The Annunciation

Pierre-Auguste Pichon, 1859
oil on canvas
Basilique Notre-Dame
Cléry-Saint-André (France)

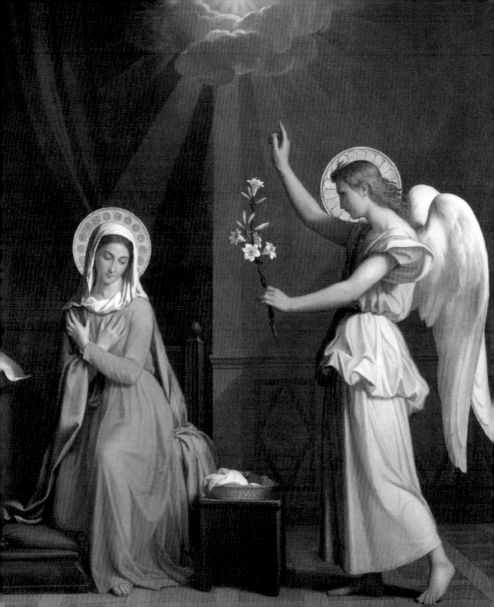

Correggio completed his painting *The Mystic Marriage of St Catherine with St Sebastian* in around 1526-1527. Mary is seated with Jesus on her lap; he holds a ring that he means to place on Catherine's finger, his hand holding hers. Everyone gazes at Catherine's hand. The background scene depicts the martyrdom of the two saints. The approval of the Virgin reinforces the approval of the patriarchal Church.

The Crowned Virgin

Jean-Auguste-Dominique Ingres, 1859
oil on canvas, 69 x 50 cm
Tamenago Gallery, Tokyo

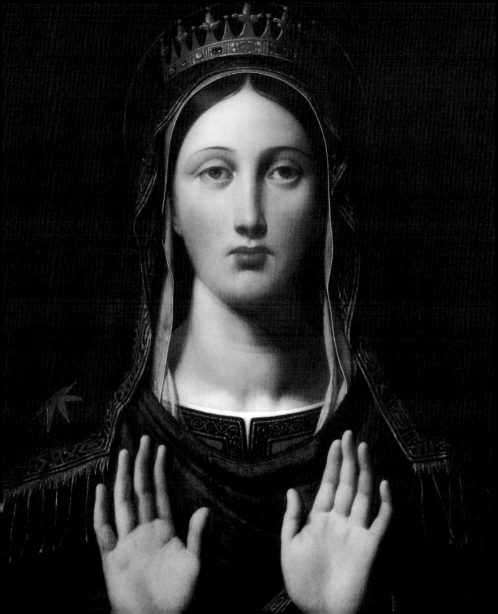

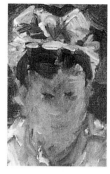

Yet the scene is created by an artist who was part of a movement that liberated itself, enabling the re-acceptance of aspects of the pagan heritage to occur within the social system.

*The Visitation* by Jacopo da Pontormo takes the human qualities of friendship and bonding between the holy subjects to high intimate level. Mary and Elizabeth are shown in profile, facing each other.

## Nursing

Berthe Morisot, 1879
oil on canvas, 50 x 61 cm
private collection, Washington DC

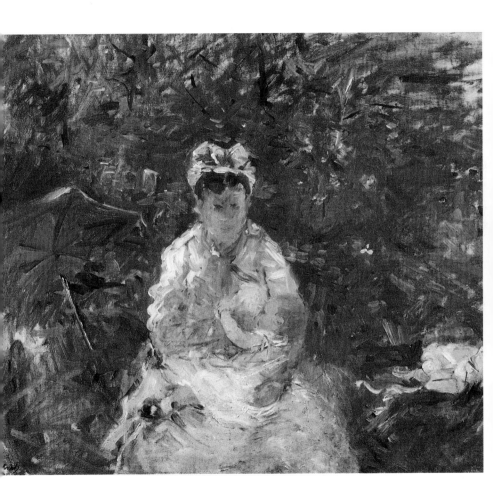

205

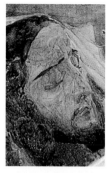

They embrace, and Mary's mother Anne stands between and behind them, facing the spectator. A young woman, located behind Mary, also faces the viewer.

In Lucas, the elder Cranach's painting of *The Virgin under the Apple Tree*, mother and child are beautiful, physically corporeal and human. The Virgin holds her nude infant, her right hand strategically covering his pudenda – a more conservative northern approach toward the maleness of Jesus.

Pietà

———

Mikhail Vrubel, 1887
watercolor on paper, 45 x 62.7 cm
Museum of Russian Art, Kiev

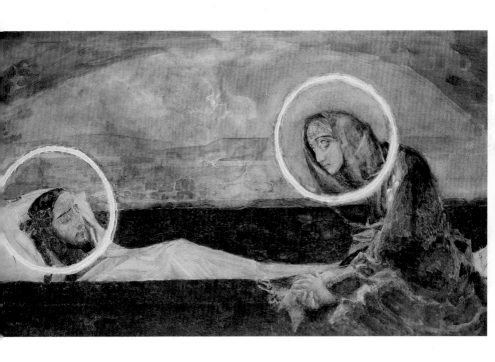

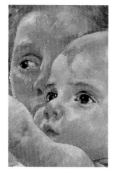

The symbolism of the tree connects the viewer with the story of Paradise Lost, and affirms Mary as the new Eve, the New Mother and Co-Redeemer of Humanity.

Rosso Fiorentino, a Mannerist, created his own interpretation of the *Pietà*. Mary the Mother, her arms outstretched in grief over the reclining body of Jesus, is the focal point of Rosso's composition, while the bride of Jesus or his favorite companion, Mary Magdalene, gently holds his feet.

Baby Reaching for an Apple

Mary Cassatt, 1893
oil on canvas, 100 x 65 cm
Virginia Museum of Fine Arts
Richmond (Virginia, USA)

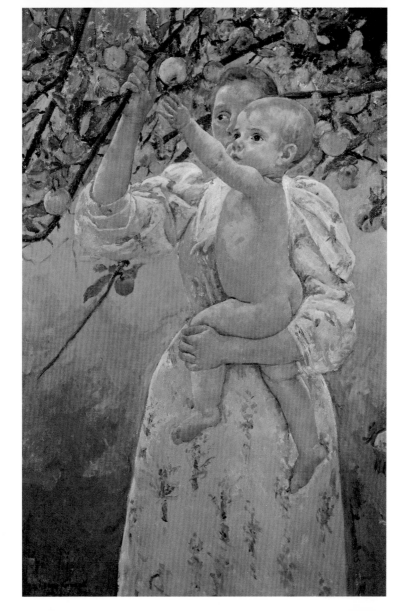

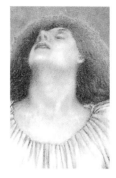

A somewhat mysterious image of the Madonna and her son was created by the Mannerist artist Parmigianino. Called *The Madonna with the Long Neck*, this work features a large, centrally-located figure of the Virgin. Her elongated seated body holds the nude child Jesus on her lap. A group of angels keeps her company, while the viewer is offered a glimpse of a freestanding column surrounded by a considerable depth of open space.

## S.O.S.

Evelyn de Morgan
late XIXth or early XXth century
The De Morgan Foundation, London

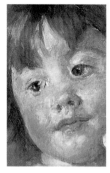

A disproportionately small male figure is next to the column. The Madonna has the look of an aristocratic lady of nobility or a queen, her divinity overshadowed by her humanity.

On the work *The Holy Family* painted by Bronzino we can see Mary and Joseph looking down at their sleeping infant. St John is about to place a kiss on his cheek. The heads of all four are crowned by barely visible nimbuses, reminding the viewer that these individuals are more than human.

Mother and Boy

Mary Cassatt, 1901
oil on canvas, 81 x 70.6 cm
The Metropolitan Museum of Art, New York

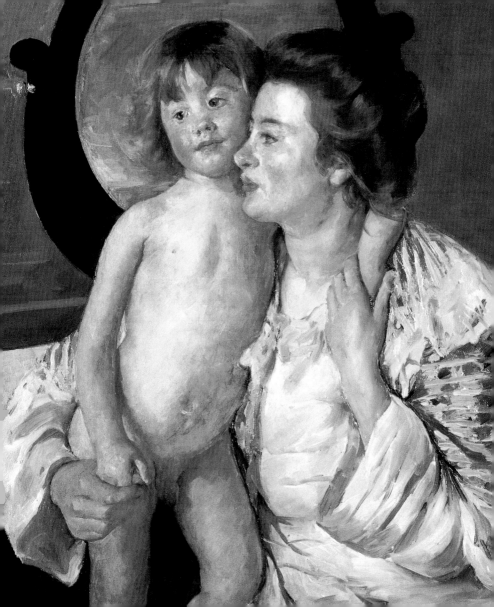

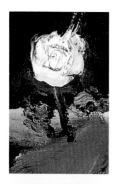

A page from an early Renaissance manuscript, *The Descent of the Holy Spirit* from *Heures à l'usage de Rome*, shows the Virgin seated among the twelve apostles as they receive a visitation from the Holy Ghost. The Holy Spirit is represented in the form of a dove, and is located above their heads – in fact, almost directly above the Madonna's head. She is the only female – as frequently is the case in illustrations of the New Testament scriptures – to receive enlightenment through the presence of the Spirit.

The Annunciation

Paula Modersohn-Becker, c.1905
oil on paper, 48 x 48 cm
Vatican Museum, Rome

*Madonna dei Palafrenieri* was painted by Caravaggio in 1602–03 for one of the altars at St Peter's, Rome, but was promptly removed, perceived by the contemporary establishment as inappropriate for that location. St Anne, Mary's mother, is shown observing the Madonna and her baby Jesus crushing the serpent. It is an allegory of the Immaculate Conception of both Mary and Jesus, the only beings ever born without taint of Original Sin, according to the Catholic dogma.

## Reclining Mother and Child

Paula Modersohn-Becker, 1906
oil on canvas, 82 x 124.7 cm
Ludwig-Roselius collection, Bremen (Germany)

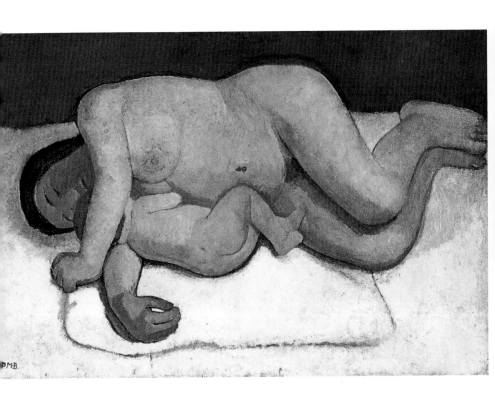

217

St Anne was a patron of the Palafrenieri family. The naturalistic approach and the theme did not entirely appeal to Caravaggio's contemporaries.

Peter Paul Rubens painted *Mary Appearing to St Ildefonso* in around 1630–32. The work is a testament to the increase in "registered" sites at which miracles have been performed and accredited to Mary's presence or intercession, or at which visions and appearances have taken place. St Ildefonso is known to have had different visions of Mary.

## Kneeling Mother and Child

Paula Modersohn-Becker, 1907
oil on canvas, 113 x 74 cm
Ludwig-Roselius collection, Bremen (Germany)

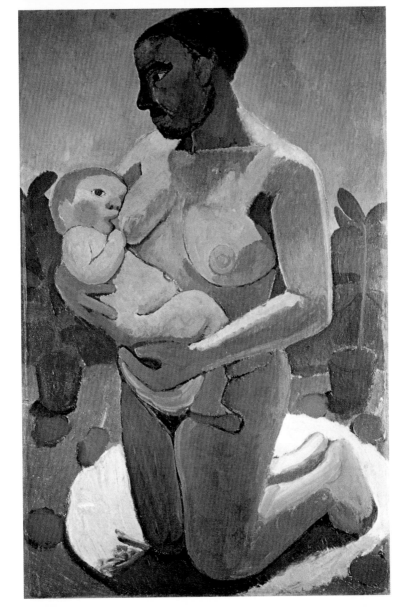

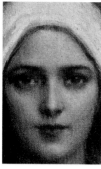

This traditional story of strategic retreat by the Holy Family was recorded by Giovanni Battista Caracciolo in 1618 in his painting titled *The Rest on the Flight into Egypt.*

Caracciolo groups together the Virgin, Jesus, and the young John the Baptist, with a lamb resting at their feet. Sitting on the opposite side of the group is the elderly Joseph, his gaze humbly fixed on Jesus.

The Immaculate Conception

C. Bosseron Chambers, 1910

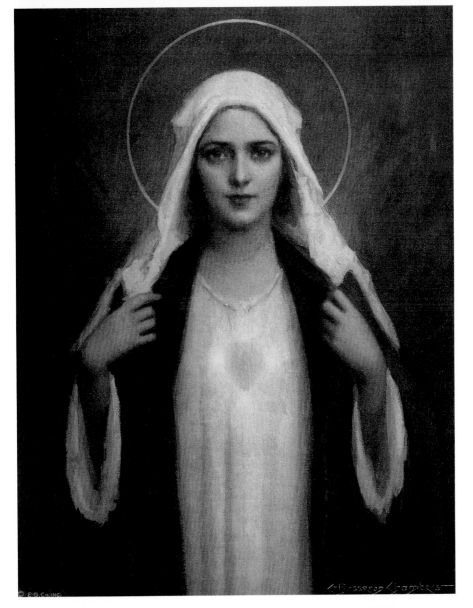

Both the Madonna and her child seem to be pensive, as if foreseeing their futures as saviors of humanity. Caracciolo, encouraged by the popular belief that Jesus looked like the Virgin, painted the infant as a perfect likeness of his mother. The belief arose from the notion that because of the Immaculate Conception, it was only Mary's genetic input that Jesus could inherit.

## Mother of the World

Nicholas Roerich, 1930s
tempera on canvas, 110.7 x 88.5 cm
Nicholas Roerich Museum, New York

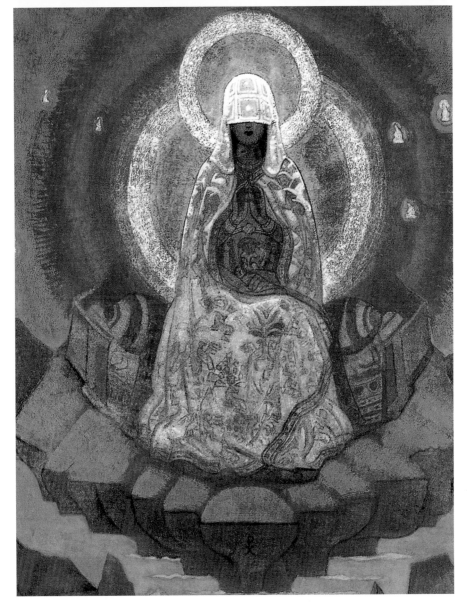

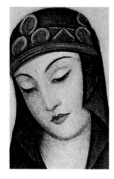

The character and the mystery of the cult of Mary Magdalene may never now be completely understood. One doctrinal theory interprets the Mother and the Bride of Christ as one and the same person. Another theory, however, sees the Magdalene as a quite separate person, genuinely the bride of Jesus and the author of one of the several Gospels rejected by the early Christian Fathers.

Madonna Oriflamma
_____

Nicholas Roerich, 1932
tempera on canvas, 173 x 100 cm
Nicholas Roerich Museum, New York

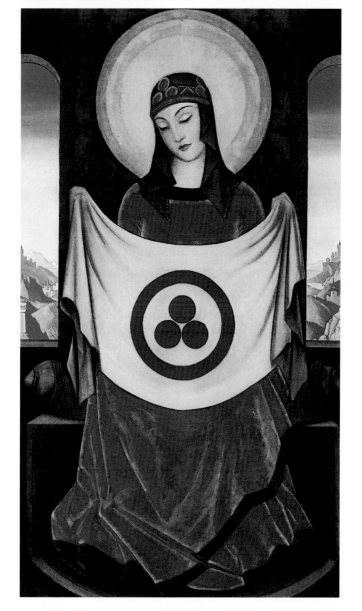

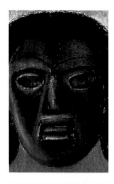

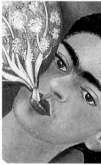

In Christian historical representation, the vision of the much earlier triple goddess is often expressed by making the three major New Testament Marys saints together – or by turning the Magdalene into three similar principles. Andrea Sacchi painted *The Three Magdalenes* during the first half of the seventeenth century.

My Nurse and I

Frida Kahlo, 1937
oil on sheet metal, 27.5 x 33.5 cm
Fundación Dolores Olmedo, Mexico City

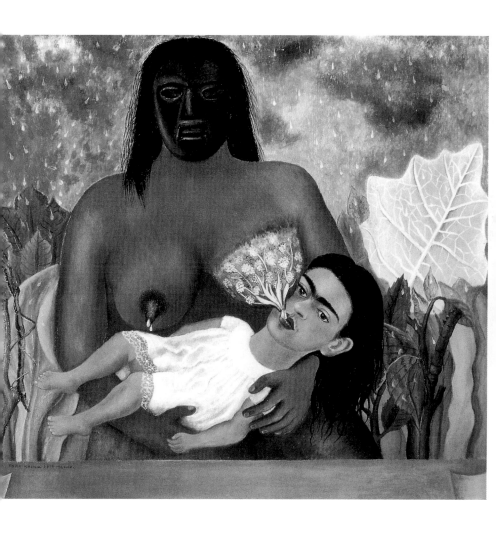

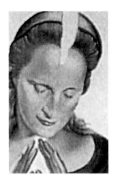

The painting called *The Immaculate Conception*, executed by Francisco de Zurbarán, shows Mary standing on the crescent moon like a lunar deity. She is being adored by cherubim and worshipped by two patrons located in the lower corners of the painting. Roses as symbols of the Virgin's divinity and lilies as symbols of her purity also feature in the picture.

The Madonna of Port Lligat

---

Salvador Dalí, 1949
oil on canvas, 48.9 x 37.5 cm
Haggerty Museum of Art, Marguette University
Milwaukee (Wisconsin, USA)

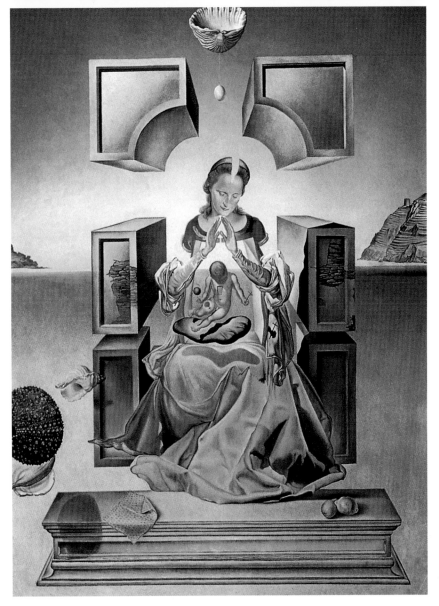

The spectacular halo around Mary's head incoporates the twelve stars mentioned by the book of Revelation, making her the Queen of Heaven and aligning her with many goddesses from the religions of antiquity. However, Mary's childlike youthfulness and innocent expression remind us that she is also the paragon of humility, an appropriate example for a patriarchal women to follow.

The Love Embrace of the
Universe the Earth (Mexico)
Me, Diego, and Señor Xolotl

Frida Kahlo, 1949
oil on masonite, 70 x 60 cm
Centro Cultural Arte Contemporaneo
Mexico City

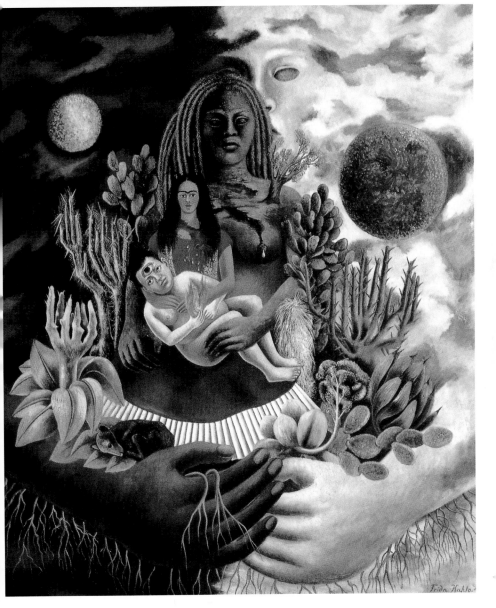

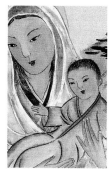

遭
難
的
天
主
教
會

一九五一年重射志

Carlo Maratta executed *The Madonna Appearing to St Philip Neri* in 1672. In luminous perfection, the vision of the Madonna and Child appears in the clouds before the adoring, ageing saint. She holds lilies, symbolic of her Immaculate Conception.

The oil painting *Reclining Mother and Child* was completed by Paula Modersohn-Becker in 1906.

The Suffering of the
Church in China in 1951

Teresa Ly, 1951
Porderone collection

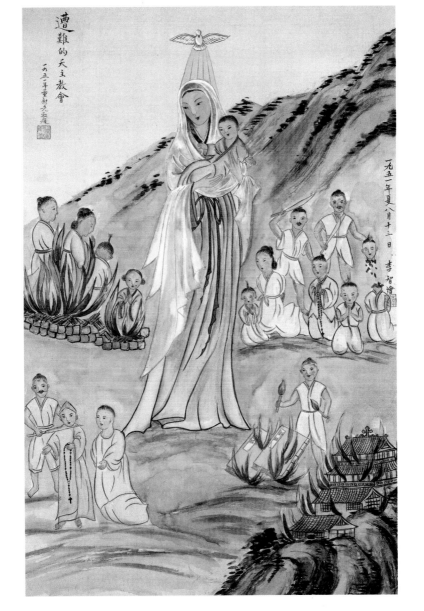

遭難的天主教會

一九五三年重刺於香港

一九五一年夏八月十三日 李智繪

233

The artist, whose contributions include her role as a founding mother of Expressionism, was inspired by the abstract elegance of African art. Here, the mother looks powerful, reminiscent of an African Mother Goddess; the child mimics her pose, as the two nudes lie asleep in loving harmony.

Nicholas Roerich completed his *Mother of the World* in the 1930s.

The Virgin of Guadalupe

Salvador Dalí, 1959
oil on canvas, 130 x 96.3 cm
Alfonso Fierro collection, Madrid

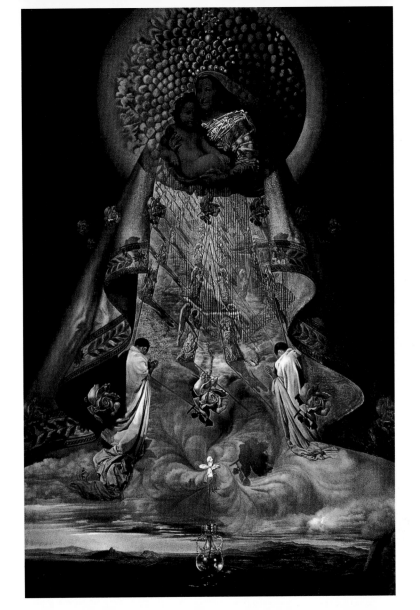

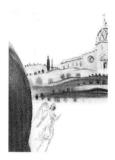

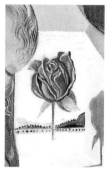

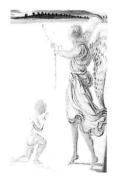

This figure of Mary-Sophia, whose face is half-veiled, represents an all-powerful but occult goddess, a Mother who loves her children unconditionally, and does not demand any gifts, honors or adulation in return.

Roerich's *Oriflamma*, executed in 1932, depicts Mary as the enthroned Queen of Heaven. A huge solar halo surrounds her head as she holds a mantle on which is a cryptic image comprising three small circles inside a large one.

Madonnna with a Mystical Rose

Salvador Dalí, 1963
oil on canvas, 71 x 71 cm
private collection

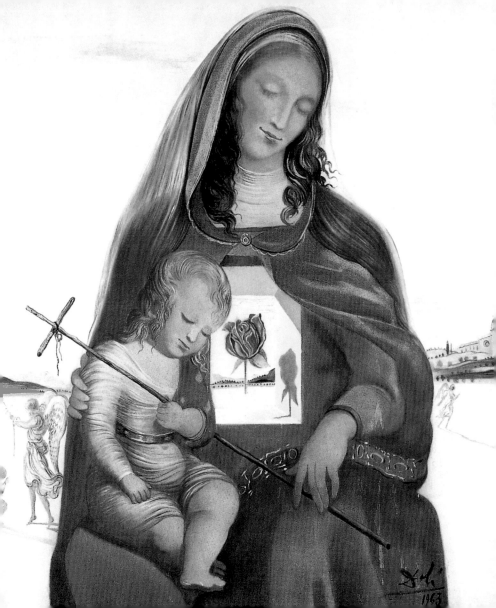

This may be intended to symbolize the Holy Trinity. Frida Kahlo agreed to exhibit with the Surrealists in New York, but on occasion made it quite clear that her style was unique and not influenced by any movement. She was not only familiar with the Marian cult of Nuestra Señora de Guadalupe in Mexico, but also versed in the Native American mythologies. Her painting titled *My Nurse* represents a new interpretation of the mother and child formula.

Carmen and Juby

Alice Neel, 1972
oil on canvas, 101.6 x 76.2 cm
Private collection

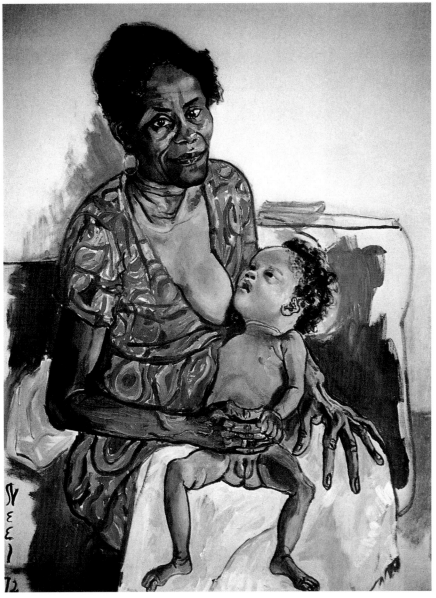

239

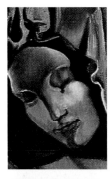

Here, the dark Earth Goddess or the Black Madonna is the miraculous Nurse, her healing milk soothing and nourishing the woman-child Frida herself. In his *Virgin of Guadalupe* Dalí was honouring the powerful and famous image of the sanctuary of the Virgin of Guadalupe, a popular focus of pilgrimage since medieval times. This grandiose Queen of Heaven, resembling the artist's wife Gala, is truly the Goddess of the Universe. She is the earth, the sky, and the sun.

Pietà (after Michelangelo)
_____

Salvador Dalí, 1982
oil on canvas, 100.2 x 100 cm
Gala-Salvador Dalí Foundation, Figueras

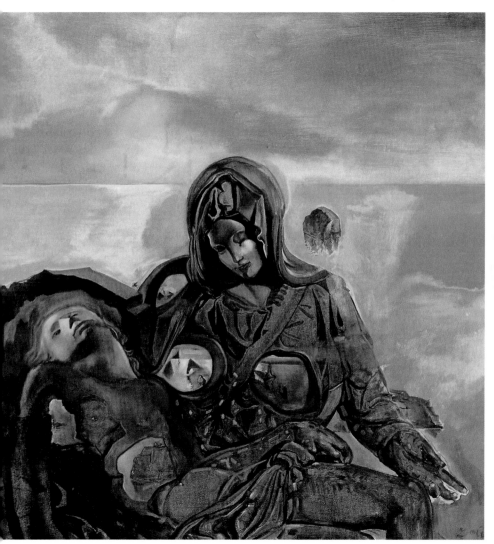

241

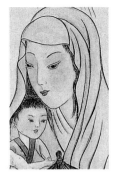

The rose, the ultimate symbol of her godly purity and female beauty and spirituality, is represented many times over. The Virgin is shown in all her glory. Her solar halo is of organic nature – a sunflower of giant proportions.

In her work titled *The Suffering of the Church in China* Teresa Ly presents a scene of the persecution of Christians in China.

Mary, Mother of the Church in China

Teresa Ly, XXth century
Instituto Missioni Estere, Parma

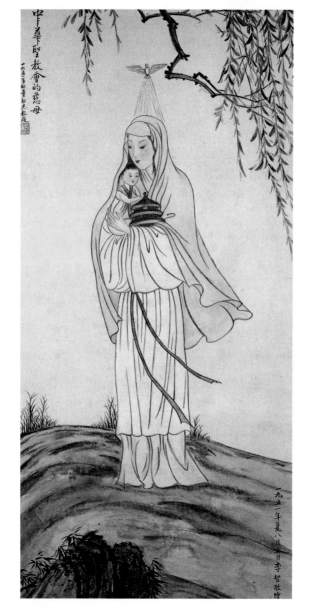

中華聖教會的慈母

一九五一年夏八月十五日李智敦繪

243

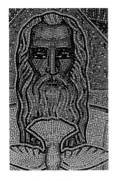

The Blessed Virgin, her infant in her arms, and the Holy Ghost hovering directly above her head, stands in the center of the composition. Around her, Christian followers are being burned and slaughtered, while churches and holy books are being put to the torch. She embodies salvation for the people not on this earth but after death.

A deeply human and sober statement on motherhood in the twentieth century is apparent in the painting by Alice Neel titled *Carmen and Baby*.

### Trinity

———

Toscano Giuseppe e Altri, XXth century
Instituto Missioni Estere, Parma

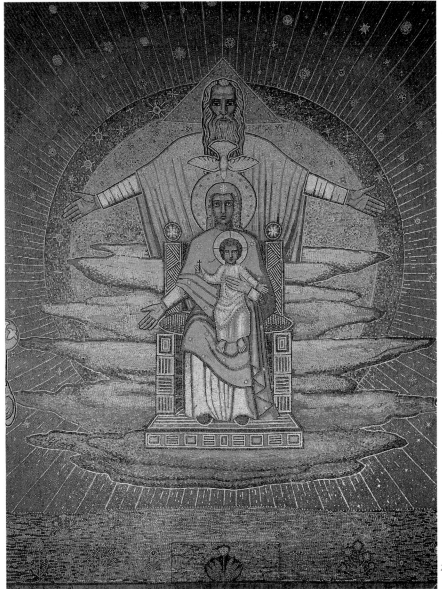

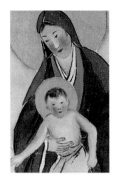

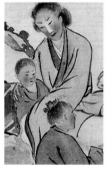

This woman, reduced by the social system to the role of mater dolorosa, is the antithesis of the young, beautiful, white, and luxuriously attired Madonnas of the Virgin and Child paintings created by Renaissance artists. It accurately reflects the status of many mothers deprived of education, human rights, and other privileges during the twentieth century. The artist took the Madonna as inspiration in expressing her point of view on the gender and racial issues of her day.

Mary, Succour to the
Christian's Body and Soul

Ch'hang ju c'j, XXth century
Instituto Missioni Estere, Parma

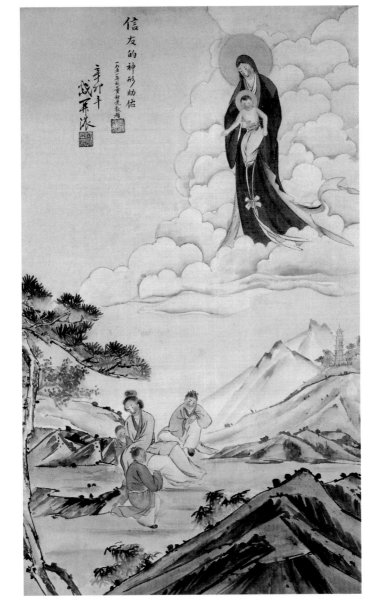

# Index